Being There

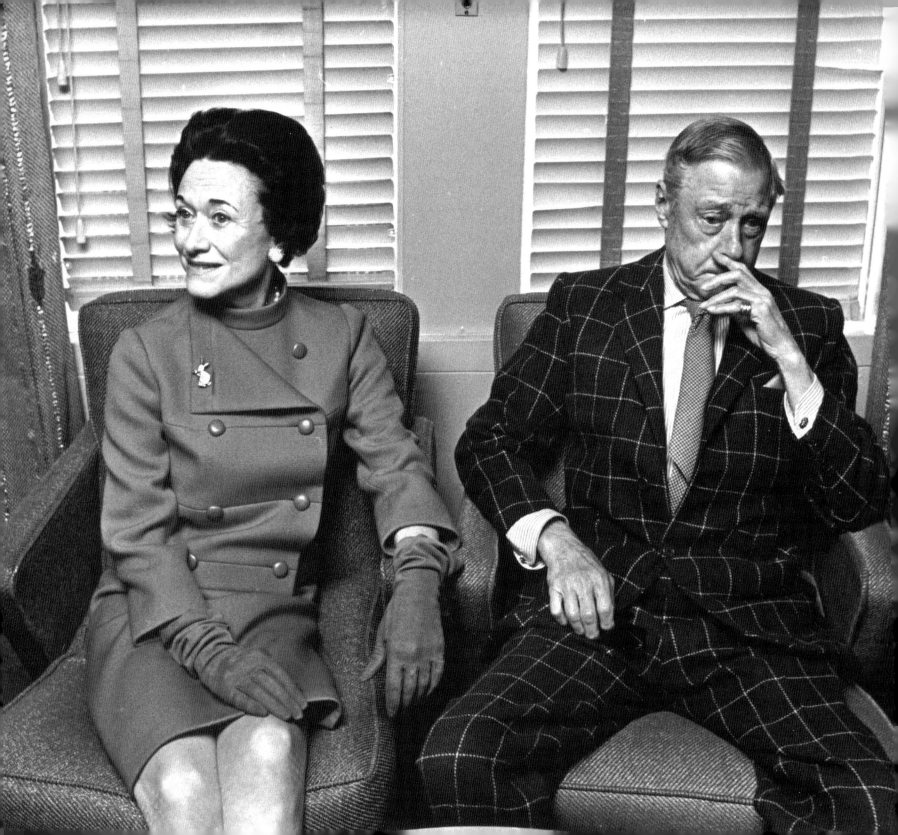

Harry Benson's Fifty Years of Photojournalism

Being There

Essay by Roger Hargreaves
Commentaries by Harry Benson

National Galleries of Scotland
Edinburgh 2006

Published by the Trustees of the National Galleries
of Scotland to accompany the exhibition *Being There:
Harry Benson's Fifty Years of Photojournalism* held at
the Scottish National Portrait Gallery, Edinburgh
from 4 August 2006 to 7 January 2007.

ISBN 1 903278 82 1 / 978 1903278 82 6

Designed by Dalrymple
Typeset in Univers and Helvetica
Printed in Belgium by Die Keure

Front cover
The Beatles, Paris, 1964
Inside front cover
Johnny Carson, Lubbock, Texas, 1970
Opposite title page
The Duke and Duchess of Windsor, New York, 1966
Back cover
President William J. Clinton and Hilary Rodham
Clinton, Little Rock, Arkansas, 1992

Foreword

Harry Benson is a great Scot who has found success on both sides of the Atlantic. It is a privilege to show his lifetime's work at the Scottish National Portrait Gallery: the first major retrospective of his career.

James Holloway, the director of the Portrait Gallery, first met Harry five years ago when he and Gigi, his wife, were visiting Scotland. We invited the editors of a number of national papers to meet Harry at a dinner we held for him in the Gallery, and to see a slide show of some of his most famous photographs. Like those news-paper men, James was spellbound and vowed that night that the Portrait Gallery should be the place to hold the Benson retrospective.

Thanks to the curator of the exhibition, Roger Hargreaves, our sponsors Burness LLP and, particularly, Harry and Gigi, that night's ambition has become reality. Harry Benson now shares a lifetime's achievement in photojournalism with a British public and through this book he will reach a far wider audience. After the exhibition closes in Edinburgh it will be shown at our sister gallery, the National Portrait Gallery in Washington. Thus the Atlantic Ocean which Harry has so success-fully crossed will be bridged again by his memorable and historic photographs.

John Leighton
Director-General
National Galleries of Scotland

James Holloway
Director
Scottish National Portrait Gallery

Acknowledgements

It is a simple thing for me to say: my career has been made so much easier by my wife, Gigi. There were many holidays – Christmases, birthdays – when I was gone or going on assignment, yet she always understood that it was my job, my life. It was what I did. And if I were going to miss so many important times with her and our two daughters – I'd better come back with a good picture or she would say, 'Was it worth it?' I never wanted her to say that. Although my name is on this exhibition and this book, I honestly could not have done it without Gigi's support and her work behind the scenes on every detail.

I would like to thank James Holloway for believing in my photography and making the retrospective a reality. Thanks also to John Leighton, the director-general of the National Galleries of Scotland and his staff whom Gigi and I have enjoyed working with, especially Anne Backhouse, Patricia Convery, Lisa Gillespie, Ross Perth, Martin Reynolds, Sarah Rodger, Kerry Stewart, Christine Thompson, Agnes Valencak-Kruger; and the designer of this book, Robert Dalrymple.

To the directors of Burness LLP who are sponsoring the exhibition, I thank you and appreciate your participation. It is very special to have a retrospective of your life's work, and to have it held in the capital of one's own country while still here to enjoy it is a double honour. Unfortunately, my parents are not here, but many of my family and friends will be celebrating with me.

My special thanks go to Roger Hargreaves for his perceptive and insightful text for this book and his expertise, patience and experienced eye in going through hundreds of photographs with Gigi in order to choose the final photographs for the exhibition. And my thanks to the designer, Jan Newton, who worked with Roger in designing the exhibition for the Gallery. Thanks to Amy Hildalgo for assisting Roger while he was in our home going through the photographs.

My thanks to those who have been there for me over the years: Roberta Doyle who first brought me to the Scottish National Portrait Gallery for a dinner in my honour and who has been a staunch supporter of my work. To my lifelong friend, Carlo Pediani, who, when I started out would drive me around Scotland on his motorbike with my camera bag between us. To Val Atkinson whose BBC documentary on my career, made during Glasgow's reign as City of Culture, was a highlight for me. To photographer Charlie McBain, my friend and colleague at the *Hamilton Advertiser* who covered for me when I went to London looking for work on Fleet Street.

Harry Benson

Dedication

I would like to dedicate this book to my daughters, Tessa and Wendy, and to my first grandchild, Mimi Landes.

Sponsor's Foreword

Burness has been a supporter of the arts for many years, in particular the art of photography. Having sponsored the exhibitions *Eve Arnold: In Retrospect, William Klein's New York* and *Magna Brava: Magnum Women Photographers*, we are delighted this year to be supporting the National Galleries of Scotland's retrospective show of the work of Harry Benson, one of Scotland's most prolific photographers of the last fifty years.

When the Beatles stepped off the plane at JFK airport on 7 February 1964, the world press was waiting. Harry Benson, however, was actually with the Beatles on the flight and achieved a unique perspective by photographing them as they disembarked from the plane to face the press.

There are parallels, we think, between Harry Benson and Burness. Our clients trust us to work in close proximity to them and, as a result, we are able to provide a similarly unique perspective.

It is a privilege to be a part of this exhibition. We hope you enjoy it.

Philip Rodney
Chairman, Burness LLP

Burness

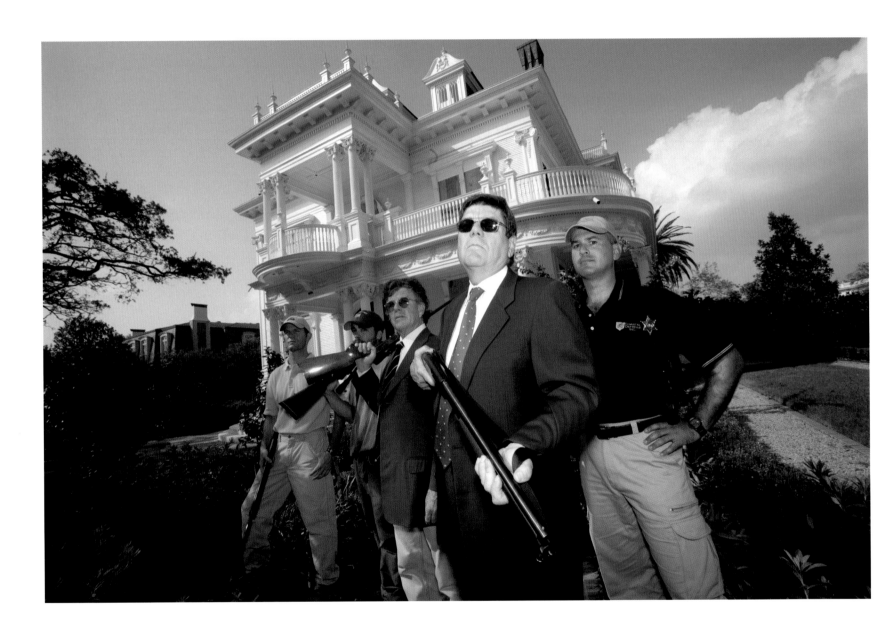

Harry Benson by Roger Hargreaves

'I'm seventy-six, Roger', Harry Benson suddenly interjects in mid-conversation, his still discernable Scottish accent hitting a high note of incredulity, as if the thought has occurred for the first time. And it is an improbable idea that this live wire of energy and appetite should have clocked up such a high mileage without showing any appreciable signs of wear and tear and without, it seems, any inclination to slow down. For over fifty years Harry Benson has been a photojournalist, producing astonishing photographs of remarkable people often at exceptional times. He has done it over and over until, after a while, I begin to think of him as being not unlike Woody Allen's character Zelig, the fictional figure lurking at the corner of the frame, peering over the shoulders of the famous at key moments of history.

In the week we met in New York in late February 2006 Harry Benson had recently returned from two back to back trips to Europe, photographing the fashion shows in Milan and visiting friends and family in Scotland. The week after he would be off again, this time to his second home in Florida from where he and Gigi, his Texan wife of forty years, would travel to Washington to photograph the White House press secretary, and to New Orleans to pick up an ongoing story on the aftermath of Hurricane Katrina.

There were always things to do, trips to make, assignments to be followed, projects to be planned. The phone was always ringing – Gigi would answer, Harry would listen in. 'I like Gigi to make my appointments.' Harry explains. 'If you make an appointment and they say no that's her no. I haven't had my no yet.' Newspapers and magazines come flooding through the door, news channels are flipped through as if constantly tapping and checking the barometer for who is hot, and which star is cooling and fading. Sport is still followed with a passion, live English premiership soccer on Fox Sports and on winter evenings his beloved New York Rangers ice hockey team. And all the time the door bell constantly chimes as packages of prints from galleries, newspapers and magazines arrive and, in turn, are dispatched, each peal of the bell sending the couple's

Calvin Fayard, New Orleans, Louisiana, 2005
Mr Fayard, foreground, and others stand in front of his New Orleans home, aptly called 'the wedding cake house' in the wealthy uptown district, prepared for potential trespassers just days after Hurricane Katrina devastated much of New Orleans in September 2005.

two small dogs, Tilly the dachshund and Daisy the pug, into a frenzy of competitive yelping.

Harry and Gigi Benson do not 'live above the shop' rather, they live in it. Their apartment, sixteen floors above the street in New York's affluent Upper East Side has been family home, office, studio and a lair from where Benson can rest and reflect upon his most recent assignment before striking out on the next one. He has often compared himself to a prize fighter, mentally preparing for the lightning jab, knowing when to apply the pressure. 'When I was out on assignment,' he recalls, 'I would often slip away and go and rest. The other photographers would never know what I was up to. Then when they'd be going off for dinner or drinks at seven at night I'd be coming out with my cameras. Drinking with the boys wasn't on my radar.' The celebrity photographer Terry O'Neil confirms the story, remembering their early years together on Fleet Street. 'We'd go to the pub and I'd be at the bar buying Harry a drink. You'd hear a siren and I'd look up and Harry would be out of the pub door and off up the street after it.'

Journalists, both photographers and reporters, have often found the adrenalin rush of being at the centre of things one moment and in the backwater the next, a dizzy and disorientating experience. The veteran American news anchor Dan Rather has warned, 'Be careful. Journalism is more addictive than crack cocaine. Your life can get out of balance.' Photojournalists who habitually cover breaking news and who are routinely invited inside the circle of celebrity and power often find it difficult to step back into a more ordinary life of relationships and routine. Too often they retell the familiar tale of heavy drinking and failed marriages.

Harry Benson has followed a different track, honing many of the virtues of the uncompromising journalist without becoming a victim of the attendant vices. Rooted and grounded, he has loved it for what it is and, in the best traditions of Scottish puritanism, maintained a hinterland of home and family. As time has gone on and their two daughters, Wendy and Tessa, have grown up and moved out, the Bensons have expanded their base, by buying and knocking through into the neighbouring apartments. They now occupy almost the entire eighteenth floor with a wrap-around roof terrace the size of a small suburban garden. The office, meanwhile, has grown into an ever-expanding archive absorbing the prolific and prodigious output of a lifetime's work: prints, press clippings, tear sheets, black and white negatives, contact sheets, colour transparencies, books and discs, filed away in dense layers of accumulated history. Benson shows me his equipment cupboard packed tight with cameras, wire transmitters, flash heads, lights and stands. He recalled:

'I must be unique in that I've worked with glass plate Picards, Speed Graphics, Rolleis, little Leicas, Pentaxes and Nikons and now I'm working with digital.' He shows me his latest camera, the Canon mark II D, an $8,000 masterpiece of engineering the size and weight of a heavy brick. The pictures he takes are remarkable. They have the resolution of a medium format camera and latitude that makes each image, taken with available light, appear as if it has been artfully lit by a team of expert cinematographers.

There are card indexes to flick through of personalities and events that Benson has photographed, spanning five decades and traversing the world. Some of these events, newsworthy at the time, have faded from memory and some of the personalities have melted away. But other names still sing out, cultural, sporting and political legends still

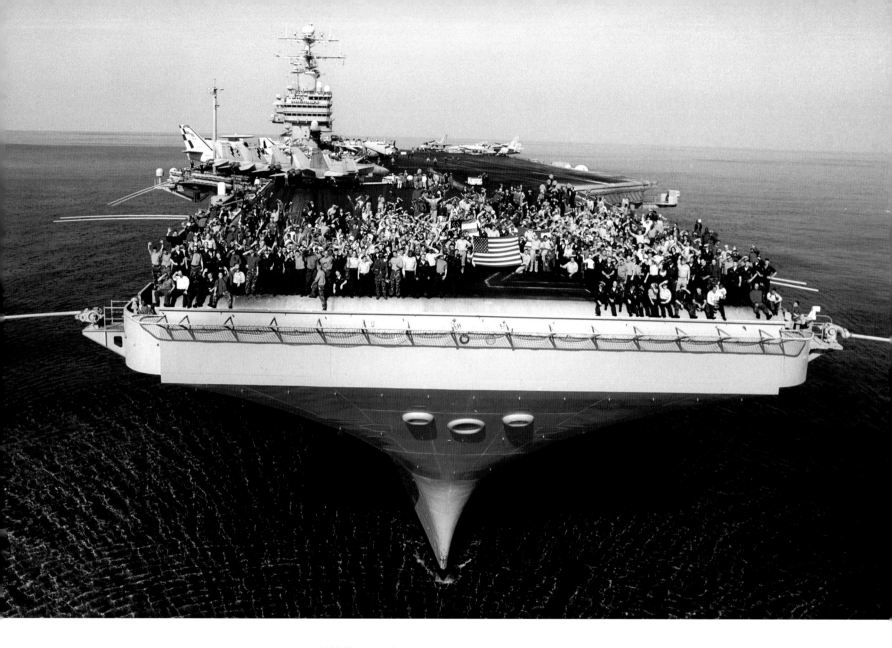

USS Theodore Roosevelt, Arabian Sea, 2001
The captain and crew aboard the aircraft carrier stood topside hoisting banners for the New York Police and Fire Departments and an American flag that had flown at the World Trade Center on 9/11. It was the lead ship from which the bombing raids of the F/A-18 fighters in the background were launched. My plane landed by tail hook and left by catapult, the most incredible acceleration you can imagine – from zero to 150 mph in three seconds.

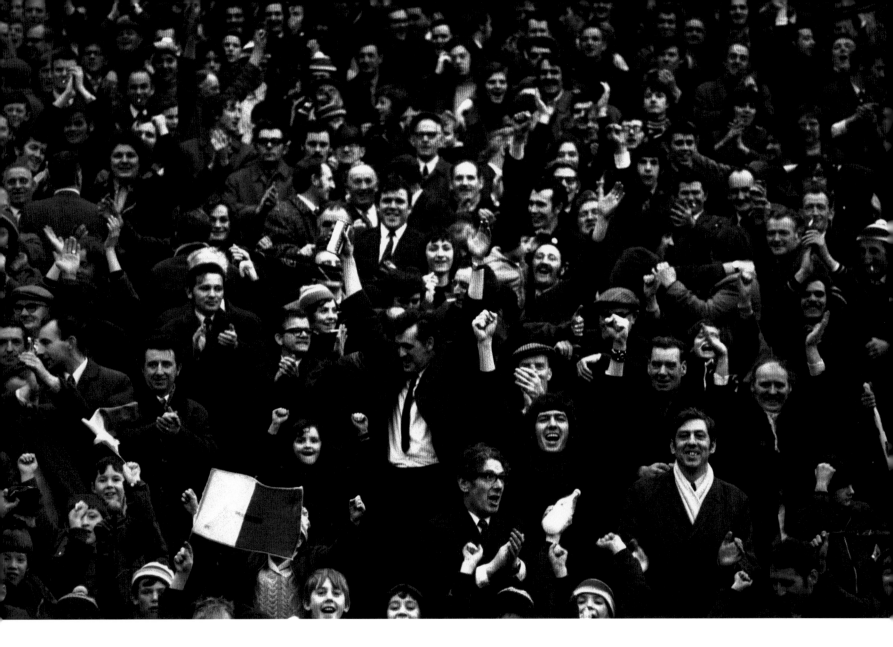

Spectators, Celtic Park, Glasgow, 1971
Ecstatic Celtic football supporters cheered as
their team scored a goal.

seared into our collective memories, names that evoke an era and mark their time: Winston Churchill, John F. Kennedy and Charles de Gaulle, Frank Sinatra, the Beatles, Truman Capote, Jack Nicholson and Muhammad Ali.

In the bedroom two large jars of hotel keys stand guard, dating from the time when hotels vied with one another to produce the most exotic and outlandish key fobs in brass and plastic. Harry liked to keep them as souvenirs, ignoring the helpful messages to 'drop in any mail box if carried away inadvertently' embossed on the side. The fobs recall times spent in Ramada and Holiday Inns, Travel Lodges and Hiltons, in rooms that became offices and ensuite bathrooms that became ad hoc darkrooms. 'I used to develop in my hotel and carry a darkroom in my suitcase.' Benson remembers, 'All American hotel bathrooms had no windows, so all you had to do was put a towel under the door, switch the light off and you were fine. You always had the enlarger on top of the commode and you were usually bare naked in there because it was so hot. When you've got a print then you've got the next process of transmitting the picture.' Between 1935 and the 1970s the Wirephoto was the principle means of

sending a press image from its source to the newspaper office. It required an expensive drum machine at either end. An electronic eye scanned the photograph and translated it into electronic impulses that could be sent through the telephone wire. Benson's memory was, 'that could go on all night. You're ready to transmit at one-thirty, but if there were problems on the line it could take until five in the morning when you'd have to be up at eight the next day.'

He was never one to shirk the grittier tasks or the mundane chores and never one to turn down a job because as he says 'you never know where it might lead'. Benson's ascent to the top of his trade has been steady and carefully plotted, and like many successful people has involved a fair deal of clawing away in the foothills to establish the first toehold.

He was born in Glasgow in 1929 and grew up during the Second World War and, like many school boys of the time, he was excited by the drama of it all and thrilled by the names of Churchill and Roosevelt. However, school failed to grip his imagination and despite coming from a respectable middle class family, he left with few qualifications aged just thirteen. 'Tangled roots', as he has called them led him into a

job as a press photographer for a local paper, the *Hamilton Advertiser*. But first he had to work his way up, picking up the basics of photography and acquiring an astute visual sensibility from odd scraps of jobs along the way. He took a job as a messenger boy in a cinema delivering Pathe newsreels, with their crowing cockerel, drum rolls and portentous commentaries from one picture house to the next. He worked for the film company, Ilford, delivering X-ray films in 'a wheel barrow around Glasgow'. Conscripted into the RAF, he served his time as a cook, disappointed that his first attempts at amateur photography failed to win him entry into the base's camera club.

Once free from the uneventful drudgery of national service he set up as a wedding photographer encouraged by a Father Duffy who gave him the nod in the direction of prospective clients. He took a summer job at Butlin's holiday camp taking happy snaps of holidaymakers for 1/6d, having fun and meeting, as he describes it, 'a lot of girls'. But by then he had caught the seductive whiff of newspapers, and like so many of his generation was captivated by the photography of *Picture Post*, and on the rare occasions he got to see it, America's *Life* magazine.

His first approaches to Glasgow newspapers were met with indifference and rejection. He went to visit the picture desk of the *Bulletin*, the morning paper of the *Glasgow Herald*: 'I put my pictures down on a tray and when I went back several days later they hadn't been touched. My father was curator of Glasgow Zoo. He knew people in the press. I remember going to the *Daily Record* to try and get a job and showing the picture editor Jimmy Morris my pictures. After looking at them he put them down and said, "you know laddie you should be feeding the animals at your daddy's zoo", which was an awful thing to say to a kid. I left there crying but more determined than ever to prove him wrong.'

By the time his bruised ego had arrived at the *Hamilton Advertiser*, a weekly newspaper covering swathes of Lanarkshire, he was ready to prove a point, learn his craft and watch the press around him, constantly weighing them up, readying himself to compete. The jobs were small and parochial: a new lectern in a church, women's guild meetings, Burns Night suppers. Occasionally there were bigger stories such as the all too frequent mining disasters or a flying visit to the region by the Queen. Harry prided himself in being first in

and last out with no job too trivial. He travelled across Lanarkshire by bus to places like Newark Hill, at the end of the bus route, where he would run into the hall, photograph an evening function then jump back on the bus as it rounded the terminal and headed back to Glasgow. Miss the bus and he would have to wait another two hours and would not be home until one in the morning. Timing became everything.

Already he had his eye focused on the next move and was feeling what was to become a habitual magnetic pull towards the centre. In the 1950s the very epicentre of British journalism was Fleet Street with its intense clustering of newspaper offices, printing presses and agencies. With it came a unique brand of journalistic culture pumped up by the proximity of the competition and fuelled on a cocktail of mythology, intrigue and alcohol. Underpinning it all was a backbone of powerful print unions and colourful press barons. Journalists, from the editor down, who were in a near constant state of being fired and then hired across the road, quickly developed an intense loyalty to themselves. That was why one of Fleet Street's most cherished pubs was christened the Stab in the Back.

Over a period of two years Harry

Benson made nine or ten trips travelling down to London on the overnight train from Glasgow and heading home again at five o'clock. It was a day's work to pound the streets, absorb the atmosphere and present himself over and over again to the picture editors of the leading national papers. As Benson tells it: 'I would get off the train and go into the toilets and shave and put on a clean shirt so you're respectable. It was awful. I went to the *Sketch* for the third time because they seemed a nice bunch of people. They had a photographer covering Scotland but I could sense it wasn't working. This time the picture editor, Freddy Wackett, gave me a smile and I went back to Glasgow thinking things are moving. There might be a chance. There were so many things that could have set me back but I knew this was how I wanted to spend my life.'

Glasgow School Boys. Kelvingrove Park, 1956
One afternoon I was walking around the park and happened upon a group of school boys up to some mischief, going for a dip in the fountain. The newspapers called it a 'Glasgow heatwave' but the temperature was only around 75 degrees fahrenheit. Looking back I now realise there were very few outdoor swimming pools available for the children at the time.

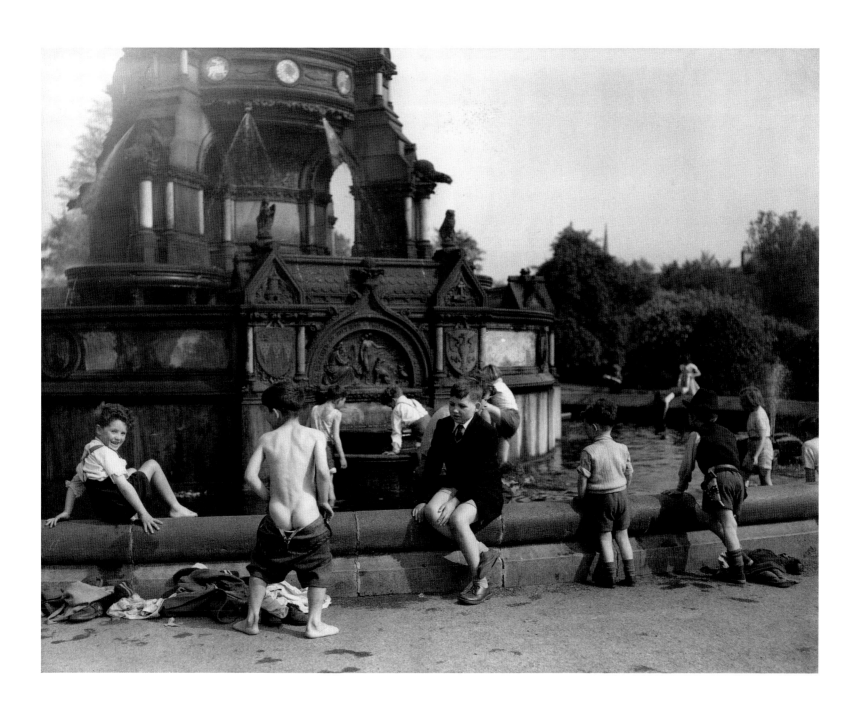

Weeks later, the call came. Harry's mother phoned him at work to tell him to ring the picture desk at the *Sketch* on Fleet Street. There had been a murder on the fifth tee of the golf course in East Kilbride. The corpse, it later transpired, was the most recent victim of the notorious mass murderer, Peter Manuel. By this time Harry had moved from the bus to a Vespa which he recollects as being 'made for the Italian beaches not for the cobblestones of Glasgow'.

It was getting dark by the time he puttered up on his scooter to the East Kilbride Golf Club. The place was eerily deserted and when he found the lone club house caretaker he wasn't entirely sure he was at the right place. The press, it seemed, had long since left. It was all over he was told. He found a policeman standing guard by a tree at the roped-off murder spot and managed to make a frame on his glass plate negative in the failing light.

Glasgow Housewives with American Sailors, 1961
American submarines carrying Polaris nuclear missiles had just docked at the Holy Loch near Glasgow. There was a controversy over whether to allow the subs to stay in Scotland, but the Glasgow housewives had no qualms about welcoming the sailors to their shores.

HM Queen Elizabeth II, 1957
The Queen had come to Scotland to open a new coal mine and she dressed for the occasion. To this day, I have never seen her looking as good again. They discovered after the grand opening that there wasn't much coal in the pit. That embarrassing mistake cost Scotland millions of pounds.

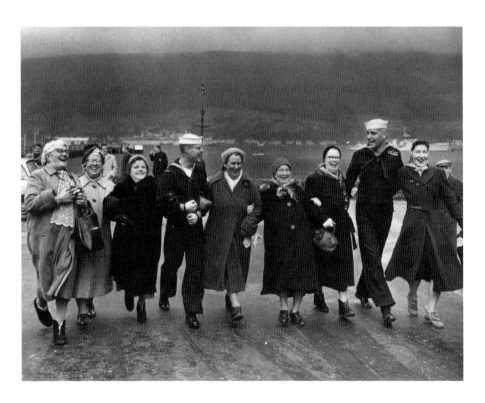

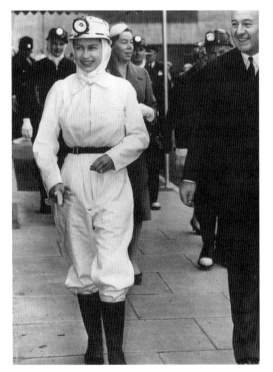

As instructed he took the plate back to the Glasgow office of the *Daily Mail*, the sister paper of the *Sketch*. As an unfamiliar face he was treated with suspicion as he waited for it to be processed and transmitted to London. Then sudden excitement; Benson was called to the phone. This was an exclusive. When the throng of reporters and photographers had arrived earlier in the afternoon they had been kept back twenty yards from the scene by the police. No one else had managed to get a usable picture. The *Daily Mail* was pleading with the *Sketch* to use the photograph. Harry had triumphed.

He left the *Hamilton Advertiser* and with a retainer from the *Sketch* began wolfing up assignments in Scotland: strikes on Clydeside, gangland murders, runaway brides made all the juicier if they could be tagged as an heiress. An award from the *Encyclopaedia Britannica*, tying for second place for the British press photographer of the year, secured a staff position at the *Sketch* in London. As a young photographer from out of town he was afforded the traditional frosty reception by the established photographers. On his first day, photographing a press call of East German film stars, he was deemed to have trespassed too far into the sight lines of a rival photographer who hit him twice on the head with his heavy Speed Graphic camera. 'Needless to say,' Harry confesses, 'I hit him back. The photographer telephoned the editor to complain. I nearly got fired, but Len Franklin, picture editor of the *Sketch*, stood by me. Afterwards, whenever I turned up for a job, the other photographers gave me a wide birth.'

Fleet Street was an oddly classless republic in which Old Etonains vied with working-class hacks who had graduated form the provincial papers in Cardiff, Glasgow and Manchester. One night, about a year after his arrival in London, he gatecrashed a society party in Jermyn Street and began taking photographs. He was tapped on the shoulder by Percy Hoskins, renowned as Percy of the Yard, chief crime correspondent of the *Daily Express*. 'Sir Max Aitkin,' he was told, 'would like a word with you'. With the realisation that this was the son of Lord Beaverbrook, Benson made his way over and was surprised by the hearty greeting to 'have a drink old boy' and further taken aback by the follow up question, 'How would you like to come and work for me?'

Benson remembers: 'I don't know why I said this, because it's the not the way I speak, but I said to him, "One is always looking to better oneself." It was as if someone else was talking. Six months passed, no word. Then one night I was with a group of reporters door-stepping outside the Caprice when Max Aitkin came out. He headed over to his Aston Martin and I followed him. As he wound down the window I asked him if he remembered me. "Of course, you're Harry Benson".'

Somewhat sheepishly Harry mentioned that when they first met there was some talk of a job. 'I haven't heard anything. I was wondering …' 'You'll hear tomorrow,' Aitkin barked as he drove off. The next day the call came from the deputy picture editor Frank Spooner, 'Old boy, you've got to come and work for us.'

Just three years ago, not long before Frank Spooner died, he and Benson had lunch together at Brown's Hotel in London. 'There's something I've always wanted to ask,' Harry pressed. 'When Sir Max Aitkin offered me the job I heard nothing for six months. What happened there?' Frank Spooner confessed, 'We did ask around and what came back was you're a good one but you're trouble.' 'OK', Harry laughed, 'Now I can die in peace.'

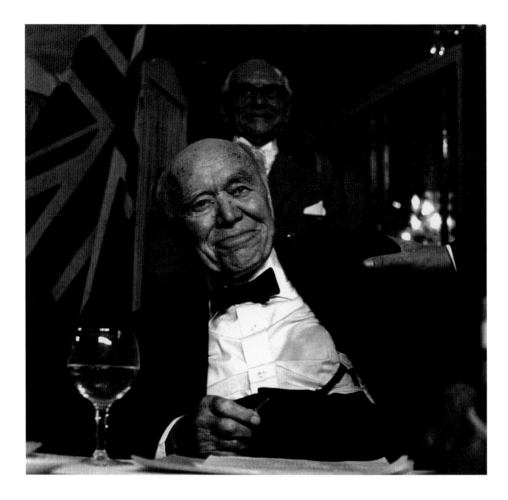

Lord Beaverbrook, Savoy Hotel, London, 1964

He seemed to relish his eighty-fifth birthday party given by another Canadian newspaperman, Lord Thomson of Fleet. Lord Beaverbrook was proprietor of the London *Daily Express* in the 1950s and 1960s when the paper was at its finest, and he was Minister of Aircraft Production under Churchill during World War Two. Beaverbrook, to my mind, was the greatest journalist I have ever met. He once gave me advice: 'Flattery, put it on with a shovel.' It actually worked. His letter to me after one assignment calling me 'a journalist of the first order' pleased me more than I can say.

It was not long before Benson came to the attention of Beaverbrook himself. The last of the powerful press barons in a lineage that extended down from Lord Northcliffe, Beaverbrook had an appetite for journalism and an instinct for what readers might want from a great and popular paper. His proclamation was that the *Daily Express* should be 'the prophet of equal opportunity and the unrelenting opponent of that system of preferred chances which gives one man an unfair opportunity over a more competent rival'. This view extended to his relationship with his staff for whom he was both motivator and protector. The iconic art deco masterpiece he commissioned from the architect Sir Owen Williams to house the *Daily Express* became an extension of himself, dark and hard on the outside, complex and labyrinthine within.

Benson's first dealings with Beaverbrook came after an incident at the Tory party conference. Harry took tea in the hotel during a break in the session. He noticed Sir Hugh Fraser and his wife Lady Antonia loitering in the foyer, and became even more interested when he spotted Lord Jellico and Lord Hailsham with them, clutching what appeared to be rolled towels. Benson trailed them from the hotel

and on to Brighton beach. At a distance he photographed them in the awkward ritual of hopping on the stony beach while undressing beneath a beach towel. Fraser spotted him and came over to appeal, 'I can't stop you showing pictures of us splashing about but give me your word you won't publish pictures of us undressing.' Benson gave him his word then wandered off for a bag of fish and chips soaked in salt and vinegar. In the glorious time before mobile phones and text messaging he was momentarily out of the loop. When he returned to the hotel he found twenty-eight messages for him from the *Daily Express* piling up at the reception. He called Ted Pickering the *Daily Express* editor-in-chief who told Benson he had to speak directly to Lord Beaverbrook. Fraser it seemed had taken the view that he should 'get on to the Beaver and straighten things out'. Benson outlined the story to

Sir Winston Churchill, Harrow School, December 1964
This was Sir Winston's last visit to his old school, Harrow. For the occasion the students added a chorus to the school song, 'And Churchill's name shall win acclaim through each new generation.' One reason I wanted to become a photojournalist was to be at the centre of world events as described by Churchill in his radio addresses during the Second World War.

Beaverbrook, explaining that he had given his word not to publish the pictures. Beaverbrook thought for a while and then pronounced his verdict. 'You know Fraser didn't have to get in touch with me. Your word was good enough. But now he has I'm inquisitive to see what you have. Send everything to London and we'll make that decision.' Harry complied. Beaverbrook told Harry, 'They should not have gone over your head. Now they are dealing with me and I didn't give my word.' The next day the pictures of the Tory leadership undressing

on the seafront were splashed across the front page of the *Daily Express* and Benson received the fallout from the incident. When Fraser spotted him at the conference he headed straight over. 'Do you know what you are Benson? You're a cad.'

Beaverbrook's instinct for journalists extended to his appreciation of designers. His appointment of Harold Keeble as the paper's art director opened the way for innovative newspaper design with a particular sensibility for photography. Under Keeble's direction younger photographers

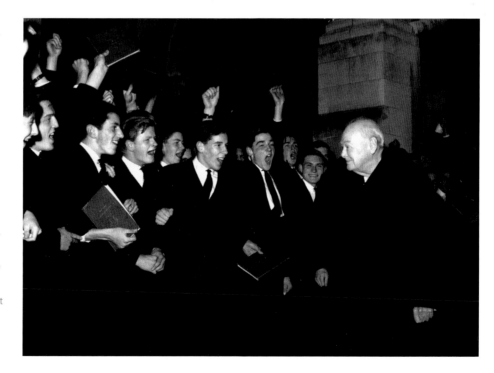

were encouraged with greater space and magazine style spreads devoted to their work. As well as Harry Benson the paper employed the young Turks of British fashion photography including David Bailey, Terence Donovan and John Cowan who set about making singular newspaper images every bit as iconic as their magazine work for *Vogue*. Keeble's designs for the *Daily Express* in the late 1950s have reverberated into subsequent eras. The design team under his direction included his protégé Michael Rand who carved out an equally influential career as art director of the *Sunday Times* magazine.

Harry Benson's memories of Keeble are affectionate recalling his particular talent for making his colleagues feel part of something special. 'I was downcast around the office complaining about not getting the best assignments. Keeble came over saying, "Harry come out for lunch tomorrow." I thought we'd be off for a pint and a sandwich at one of the usual Fleet Street dives; Poppins or the Wig and Pen. No. We were off in a cab to the Savoy Grill. He ordered Krug and wanted to discuss pictures with me. Hugh Cudlipp [editor of the *Daily Mirror*] was there and Keeble introduced me as "one of our great young photographers". He made me feel like a million dollars.'

An equal impression was made on a winter evening on assignment to doorstep Audrey Hepburn at her London hotel. This time he was outside the Savoy staking out the film star from across the street, waiting in the cold from late afternoon for a chance sighting. While he waited *Life* magazine photographer Alfred Eisenstaedt arrived, was whisked inside and got what Harry described as the 'treatment'. There was, it appeared, another way of doing things and another league to play in.

In 1960, after just two years working on the *Daily Express*, Harry moved to work for the *Queen* magazine. What had once been a dowdy society title was being transformed by its mercurial proprietor, Jocelyn Stevens, into the indispensable style guide of the early sixties blending fashion with art, film, politics and culture. Fashion photographer Norman Parkinson guided photographic content as associate editor and John Cowan, Helmut Newton and Guy Bourdin were given free rein in voluminous fashion spreads that were interleafed with documentary style essays by photographers including Roger Mayne and the American Bruce Davidson. Harry

Benson brought a tougher, journalistic edge to the mix. For the first time he was working with colour and *Queen*'s society roots provided the essential calling card for entry into the inner sanctum. One of his most memorable spreads was on the Shah of Persia and his glamorous, westernised wife, Queen Farah.

After another two years he returned to the *Daily Express*. The paper was in expansionist mood and had recently opened an office in New York as a filter for American coverage. This was the bait that brought Harry back into the fold. He had spotted an opportunity to try his hand in the American sphere, albeit for an English newspaper. But first he had to re-establish himself and work on a broader stage of international conflict covering the trouble zones of Cyprus and Algiers. Back at the paper he was called in to join in a group shot of the *Daily Express's* growing roster of photographers. Harold Keeble had spotted a similar shot in *Life* magazine and realising he had almost as many photographers on call, and not to be outdone, offered them up to the readers of the *Daily Express* as the English version of *Life*. The stunt backfired. When Beaverbrook saw the image he concluded this was graphic evidence of chronic overstaffing.

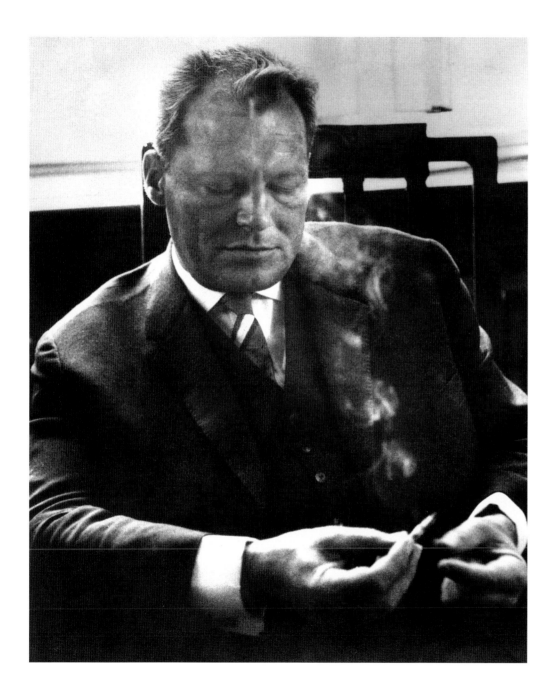

Harry was pencilled in for a particularly important assignment. It was a year on since the first wave of independence of the former colonial states in Africa and the *Daily Express* was planning a major story to follow up their progress. Their leading writers were being lined up in preparation and Benson was to be the photographer. 'My bags were all packed. I'd had shots for everything; yellow and green fever. It was a big pompous story and I was rather proud to be going.'

Then at eleven o'clock at night, days before he was scheduled to leave, the night editor of the picture desk phoned to say there was a change of plan, instead they wanted him to go to Paris the next day to

Mayor Willy Brandt, Berlin 1961
On the day the Berlin Wall started going up I got on the first plane out of London for West Berlin. Coincidentally – and coincidence plays a large role in a photojournalist's life – a first rate Fleet Street reporter named Donald Edgar was on the flight. He spoke perfect German and suggested we try to find the mayor. We got to Brandt's office just as he was leaving, but he agreed to an interview and some pictures. Brandt discussed the horrendous situation of Russian troops encircling and closing off the corridors in and around the city, and he let us ride with him in his car to see the drama unfolding.

The Beatles, New York, 7 February 1964

When the Beatles stepped off the plane they were greeted by shouting newsmen and photographers but only a few fans. The fans had been held back by the police. I was the fifth off the plane and had arranged for them to turn around and look at me before disembarking. London was expecting thousands of screaming fans and nothing short of that would have been acceptable for the front page of the paper after the way the Beatles had been received in Europe. I never bothered to wire the photos back to London since there had been no hysterical crowds, but the photo has taken on a whole new meaning with time.

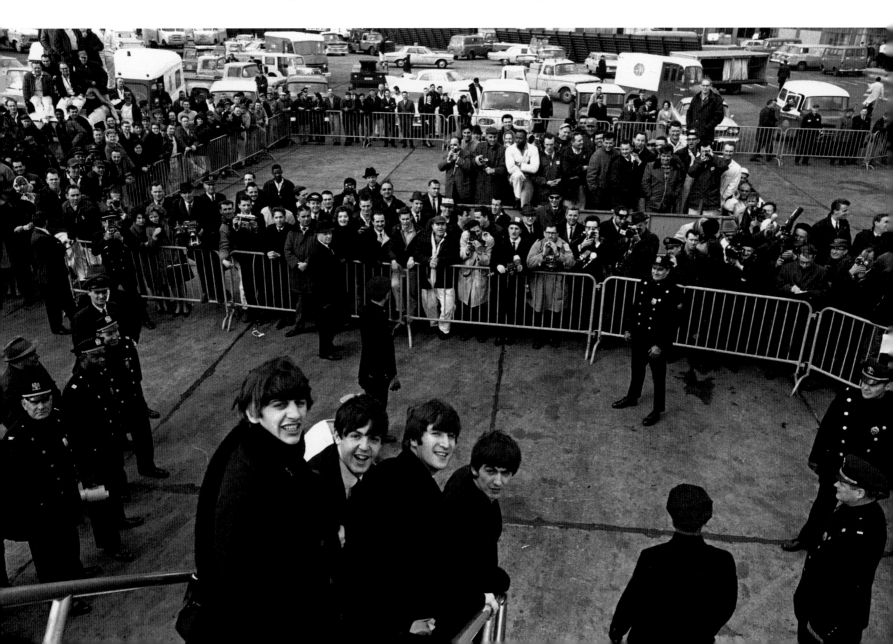

photograph the Beatles. Harry was crest-fallen. 'If you think of yourself as a big journalist you don't want to cover a rock group especially one that hasn't quite broken out yet. So I phoned the night editor to talk him out of it. "Alright Harry," he sympathised, "I understand." But then Tony Davies [the editor] phoned back and said "No Harry, you're going to Paris." I was so upset.'

While he was disappointed he was enough of a professional not to show it and buckled down to the job in hand, trailing the Beatles round Paris to pavement cafés and souvenir shops and on to their nightly performances at the Olympia. Derek Taylor, a journalist for the *Daily Express* in Manchester who later became the Beatles' publicist, smoothed the way for Harry. He quickly graduated from being, as he describes it, 'a nice guy in the crowd to someone they don't mind having a drink with. I was working and I wanted to get close to them. They didn't like the photographer who'd been sent before, a guy from Liverpool. I know why they didn't like him. They told me. He was ugly and the worst thing you could be around the Beatles was ugly. I was OK.'

One evening, when they were having a drink after a performance at Olympia, Ringo Starr let slip, 'That was some pillow fight we had last night.' Harry was intrigued but as there was a photographer from the *Daily Mail* sitting with them, kept quiet. Two nights later he was invited back to their room for more after show drinks. 'They were dead beat and things were winding down when Brian Epstein burst in with a telegram. 'I Want to Hold Your Hand' was number one in America. They were going to America. They were going to be on the *Ed Sullivan Show*.' Epstein and Taylor left, leaving Harry alone with the Beatles. It was three in the morning. He suggested, 'How about that pillow fight you were talking about.' There were mutterings of 'yeah, yeah, why not' when John Lennon joined in. 'No,' he said, 'it's childish. We can't go around looking like juveniles all our lives. We've got to be a bit more serious.' The others chorused back, 'yeah, yeah John, right John.'

Benson remembers that Paul McCartney was sitting there 'looking deadly serious. Then John came up behind him and hit him on the back of the head with a pillow. They were off.' Benson took a roll of film on his Rolleiflex but there is one frame that sings out; an exquisitely choreo-graphed cascade of exuberance tightly framed and perfectly balanced. It has become one of Harry's most memorable pictures and provided his ticket, not just to America but into the heartlands of American photography.

A week later, Harry was part of the Beatles entourage that included Phil Spector and the Ronettes as they flew to New York. Waiting for them on the tarmac was photographer Bill Eppridge who would later distinguish himself at *Life* magazine. In John Leongard's oral history of *Life* magazine Eppridge recounts his first sighting of Harry Benson: 'I was in the press pool at JFK and introduced myself to the photographer next to me. He was Eddie Adams from the Associated Press [whose 1968 photograph of the assassination of a Vietcong in Saigon would win the Pulitzer Prize]. I said, "If you had your choice, what position would you like to have?" We both agreed we would want to be right behind the Beatles as they came out of the plane, looking down, across them, over this whole huge mob.'

'The plane pulled up to the ramp and the door opened. A Pan Am stewardess came off, and out came the four Beatles. Then this character came out right behind them,

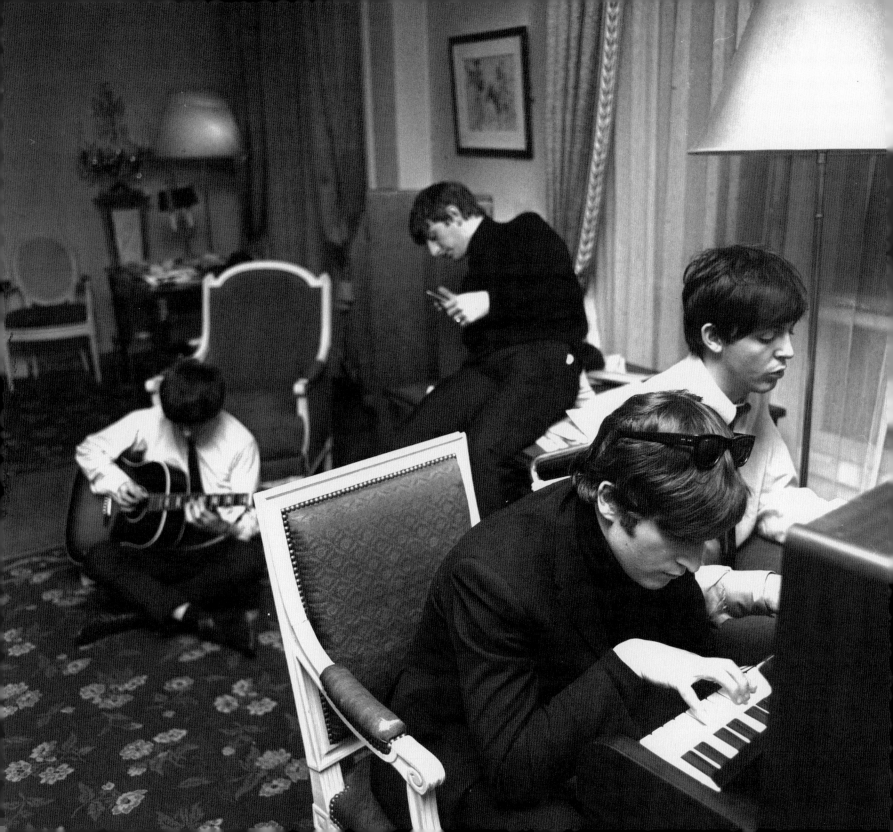

The Beatles, George V Hotel, Paris, January 1964

John sat down at the piano and started to play; Paul joined him. They quickly became engrossed, oblivious to my presence. George picked up his guitar and Ringo sat quietly listening. First came the melody, then the words. They were composing 'I Feel Fine'.

John Lennon, Chicago, 1966

After John told British journalist Maureen Cleave the Beatles were more popular than Jesus, there was a terrible backlash in the American Bible Belt. People were burning their records, DJs were refusing to play their songs on the radio, and there were death threats against the group. When I arrived in Chicago, John had already given a press conference in which he apologised. He was sitting in his hotel room, almost crying, saying, 'Why did I say that, why did I say that?' The other Beatles were angry with him for the remark, which had cost them some fans.

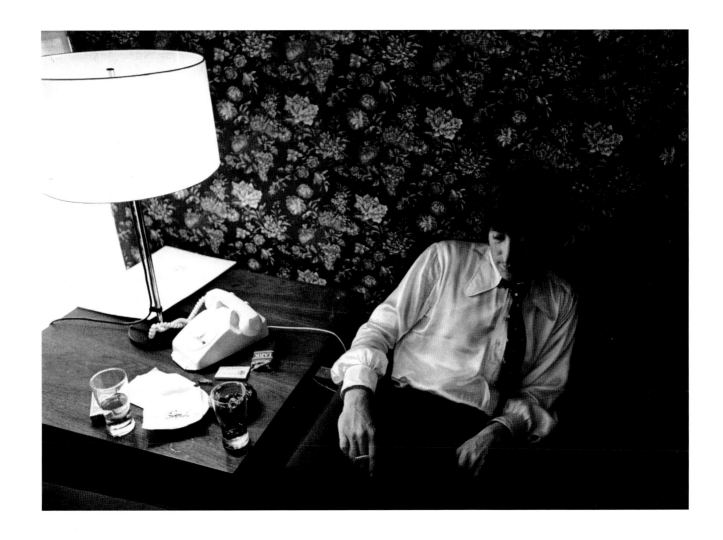

and he started posing them. Eddie and I looked at each other and said, "Who is that?" We had no idea: it was Harry Benson's first trip to the United States. It's been going on like that for years. Every time you'd know what the best spot was: who shows up in that spot? Harry Benson.'

Harry had arrived and rather than slipping into the country, he had burst through the front door. He stayed with the Beatles story, photographing the screaming crowds, their appearance on the *Ed Sullivan Show*, and their trip to Washington and then on to Miami which Harry thought 'was heaven, sunny and happy'. In his hotel room he switched on the television to encounter the screaming face of Cassius Clay goading Sonny Liston. Clay was training in Miami in the small Fifth Street Gym preparing for his world heavyweight championship. Harry went down to take a look. The Beatles, meanwhile, were looking for things to do. Harry suggested a trip to meet Clay at his gym. John Lennon was having none of it as he wanted to meet Charles 'Sonny' Liston instead, 'the guy,' he'd concluded 'that's going to kill him'. Harry promised to see what he could do. Piling them into a car under the delusion that they were off to meet Liston, instead, they headed for their

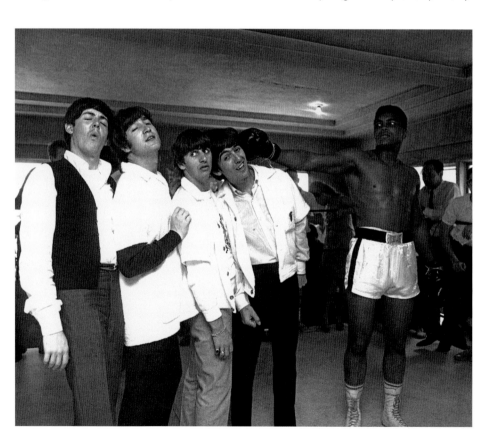

The Beatles and Cassius Clay, Miami, 1964
We flew to Miami for the Beatles second appearance on the *Ed Sullivan Show*. Watching television, I saw Clay shouting that he would win the heavyweight title from the champ, Sonny Liston. I thought this would make a good picture, but John wanted to meet the champ instead. Liston didn't even look up at me and said, 'I don't want to meet those bums.' Thinking they were going to meet Liston, I took them to meet Clay at the Fifth Street Gym. Clay completely overwhelmed them shouting, 'I'm the greatest. You're pretty, but I'm prettier.' They had never taken a back seat before. John told me I had made a fool of them and he wouldn't speak to me for a month.

Cassius Clay, Miami, 1964
Moments after Clay defeated Sonny Liston for the title Heavyweight Champion of the World you could see the tension in his eyes. Clay changed his name after the fight and would not answer reporters' questions unless they referred to him as Muhammad Ali.

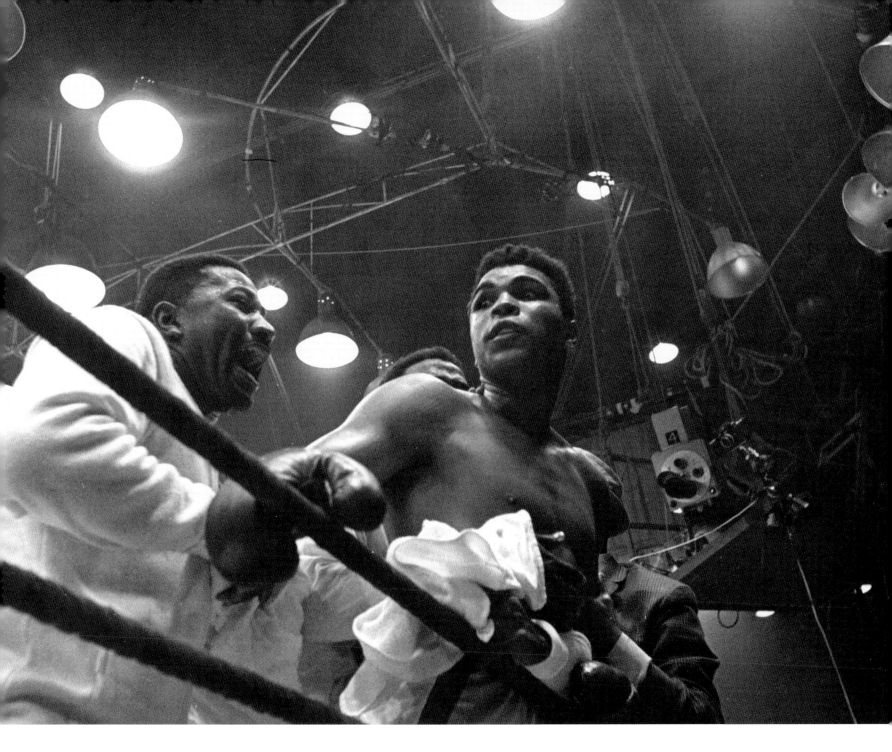

encounter with Clay. 'Who's the greatest? Who's the most beautiful?' Clay jabbed, drawing them into the ring and quickly established himself as the ringmaster with the Beatles as a troupe of clowns. Lennon hated it, first blaming Harry for setting them up and then he refused to speak to him for a month.

They went their separate ways with Benson flying to Jamaica to photograph Ian Fleming before returning to Miami for the Liston-Clay fight. 'Things' as Harry likes to say 'were moving'. By now aged thirty-four and a seasoned Fleet Street photographer, he had arrived in America with relatively little; no ties, no mortgage and no savings to speak of. He moved to New York as a freelancer on a retainer from the *Daily Express* eager to accept any out of town jobs that would pay his hotel expenses. Once again, he was where he felt most comfortable, an outsider clawing for a foothold, but this time looking up the cliff face of a mightier and taller mountain.

Many of the assignments he took for the *Daily Express* were of stories that charted the fate of the British in America. Readers of the paper were inevitably interested in the exploits of familiar British names as they stepped out to compete on the larger American stage. He covered sports stars like Tony Jacklin at the Masters and the racing drivers Jim Clark and Jackie Stewart at the Indianapolis 500. The stories were given added frisson when Harry's pictures caught something of the spark of friction generated between the meeting of two distinctly different cultures. British royals riding trolley cars, being greeted by

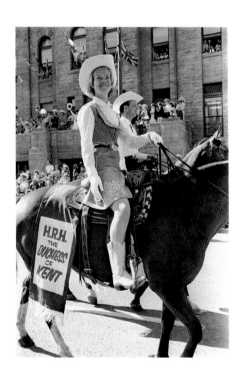

Alfred Hitchcock, Los Angeles, 1969
I met the great director on the set of his film
Topaz when I delivered the movie footage
I had shot for him in Havana as background
information for the film.

The Duke and Duchess of Kent, Calgary, 1966
The duke and duchess were leading the parade
that opened the annual Calgary Stampede.
Festivities included covered wagon races and a
rodeo. The duke and duchess seemed right at
home as they greeted the cheering fans.

Jim Clark, Indianapolis, 1965
A few days after the photograph was taken, Clark
won the Indianapolis 500 in a Lotus, leading the
race for 190 out of 200 laps. His twenty-five-race
winning streak ended in 1968 when he was killed
as the back tyre of his car failed and he crashed
into a tree in a Formula Two race in Germany.

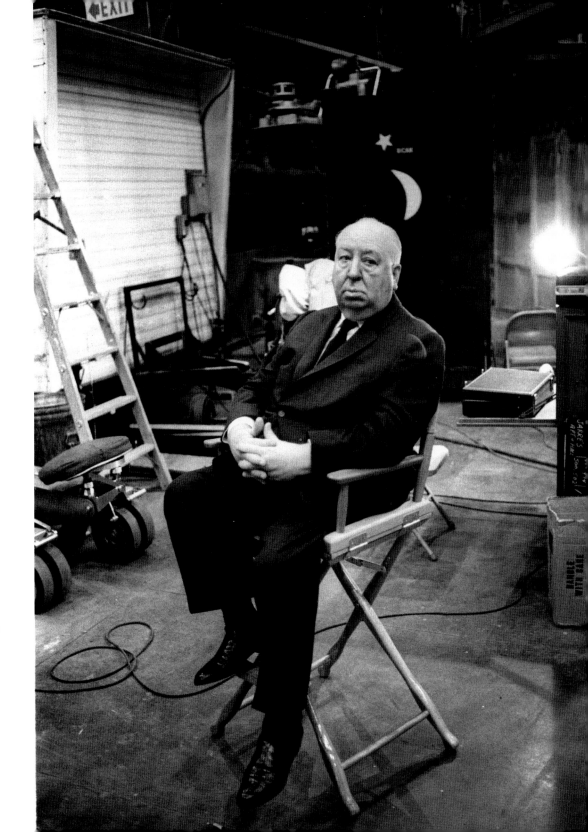

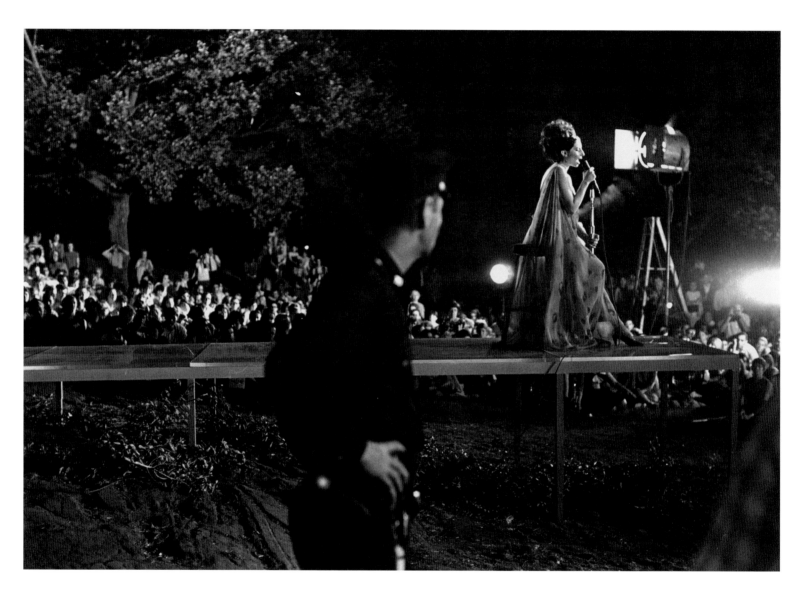

Barbra Streisand, Central Park, New York, 1967

It was the first free concert by a major star in Central Park and the fans flocked to see Barbra. Although her performance was a huge success, she lived up to her legendary reputation for being difficult. She looked at the photographers and told us to 'go away' as she headed for her trailer after the concert which was filmed for television and has become a cult classic.

Dr Michael Ramsay, Archbishop of Canterbury,
Las Vegas, 1967
Walking through the Dunes Hotel after giving a speech
at the Las Vegas Convention Center, it appears as if a
policeman is handcuffing the archbishop and
marching him off to jail. In actuality, he was
holding up the archbishop's gown so it would
not drag on the floor of the hotel.

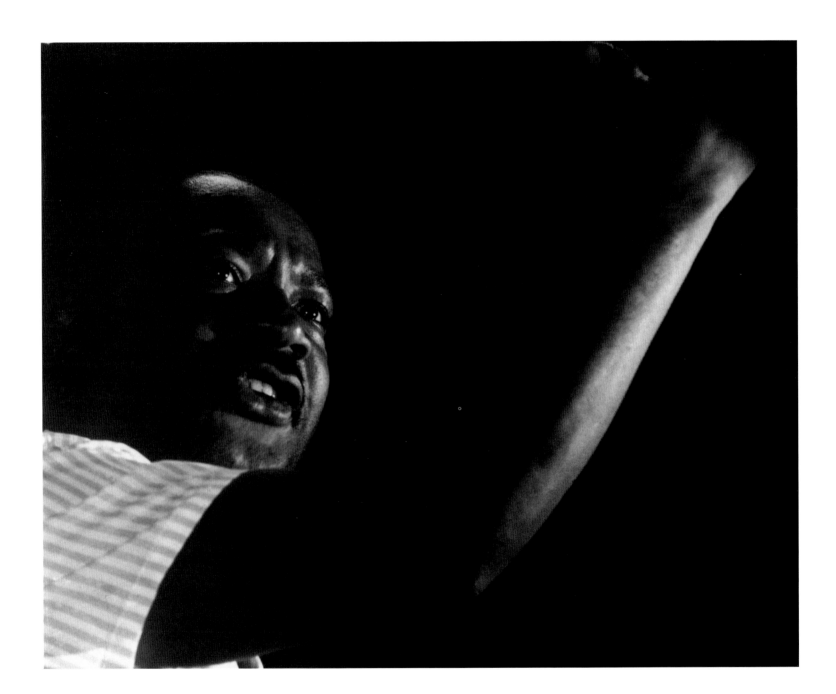

pom-pom wielding cheerleaders or in parades with large signs attached to their horses to let the crowds know who they were, created both amusement and bemusement back home. The Archbishop of Canterbury's habit of walking with his hands clasped behind his back had the unintentional effect of making him appear as if he was under arrest when he was led through a hotel lobby by a state trooper, in the incongruous setting of Las Vegas. Perhaps the most violent collision came, once again, from the Beatles, this time in Chicago in 1966 when a contrite John Lennon was photographed contemplating the backlash whipped up in the southern Bible Belt over his innocently sarcastic aside that the Beatles were bigger than Jesus.

But Benson was as interested in the stories about America itself, following his outsiders probing quest into the heartland of his adopted home and making work that would appeal to the American magazine market. The decade between the assassination of John F. Kennedy and the resignation of Richard Nixon was one of America's most troubled with the added edge of it

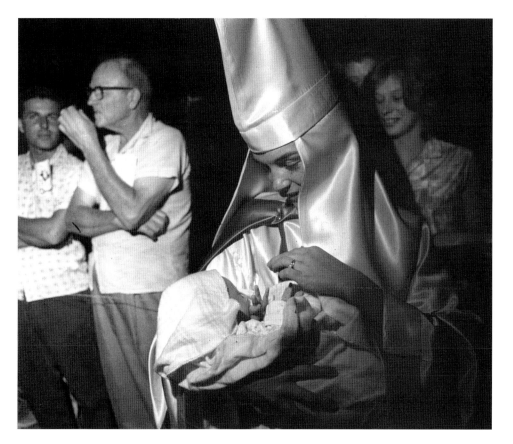

Dr Martin Luther King Jr, Canton, Mississippi, 1966
We had just been tear gassed for pitching tents for the night in a school yard during the Meredith March for racial equality. Never giving in to despair, Dr King began to speak to the crowd of peaceful marchers who were angered by the treatment they had received, telling them not to be disheartened.

Mother with Child, Beaufort, South Carolina, 1965
The Ku Klux Klan meeting I attended at the invitation of Imperial Wizard Bobby Shelton was shockingly just like ones I had seen in the movies. However, I was surprised to see a woman dressed in the robes with an infant in her arms. I couldn't believe this type of pagan ritual with burning crosses could go on in a civilised society.

unfolding in the public gaze through television and the print media. Vietnam, the civil rights movement, rioting in the inner cities, the slaying of the Kennedys and of Martin Luther King – and the outpourings of public grief triggered by the murders – were played out on the nightly news and in the daily papers. It was a highly visual turmoil and Harry Benson proved to be one of its most persistent chroniclers likening the experience to witnessing, at close hand, a collective, national nervous breakdown.

In the aftermath of his beating of Sonny Liston, Cassius Clay renounced what he called his slave name, demanding to be known henceforth as Muhammad Ali. Two years before Harry's arrival in America, Martin Luther King had led the march to Washington at which he had declared, with the poetic oratory of a persuasive preacher, 'I have a dream' before evoking, 'the old Negro spiritual, "Free at last! Free at last! Thank God Almighty, we are free at last!"' Black America was asserting itself against decades of social and economic inequality with a movement that was becoming polarised between a radical Nation of Islam and a moderate, but equally uncompromising, alliance of southern Black Christians. Harry took up the story photographing the

Watts and Newark riots and joined the Meredith March through Mississippi alongside Martin Luther King and Stokely Carmichael. In Canton, Mississippi, he was left vomiting and choking from the tear gas fired at the marchers.

Like any good journalist he looked into the flip side of the story and negotiated access to the Ku Klux Klan. He arrived at a rally of the United Klans of America in Beaufort, South Carolina, in the company of the Imperial Wizard, Robert Shelton. Amongst the cross lighting and parades, Benson was particularly troubled to spot robed women nursing infant children. 'Some of my boys can get mighty carried away,' Shelton warned, ' Leave when the women and children leave.'

On 4 April 1968, against this backdrop of festering tension, Martin Luther King Jr was shot while on the balcony of the Lorraine Motel in Memphis, Tennessee. America was pitched back into the night-mare of violent death and public agony. Benson flew to Atlanta to cover the funeral arriving in advance of the plane that was carrying the body of the slain civil rights leader. He stepped out of the photo-graphers allotted area on the tarmac for a moment and caught a remarkable

Mrs Martin Luther King Jr, Atlanta, 1968
Family and friends at the funeral service for her husband surrounded Coretta Scott King.

overleaf, left to right

Dr Martin Luther King Jr, Atlanta, 1968
Dr King's body lay in state in the Ebenezer Baptist Church in the stifling heat as people cried and mourners passed by the open casket.

Mrs Martin Luther King Jr, Atlanta, 1968
Mrs King and her four children flew from Memphis where her husband had been slain to Atlanta for his burial. As Dr King's body was being taken from the plane, there was just a moment when the family came together in the doorway.

Mourners, Atlanta, 1968
Grief-stricken mourners lined the path of the hearse carrying Dr King's body.

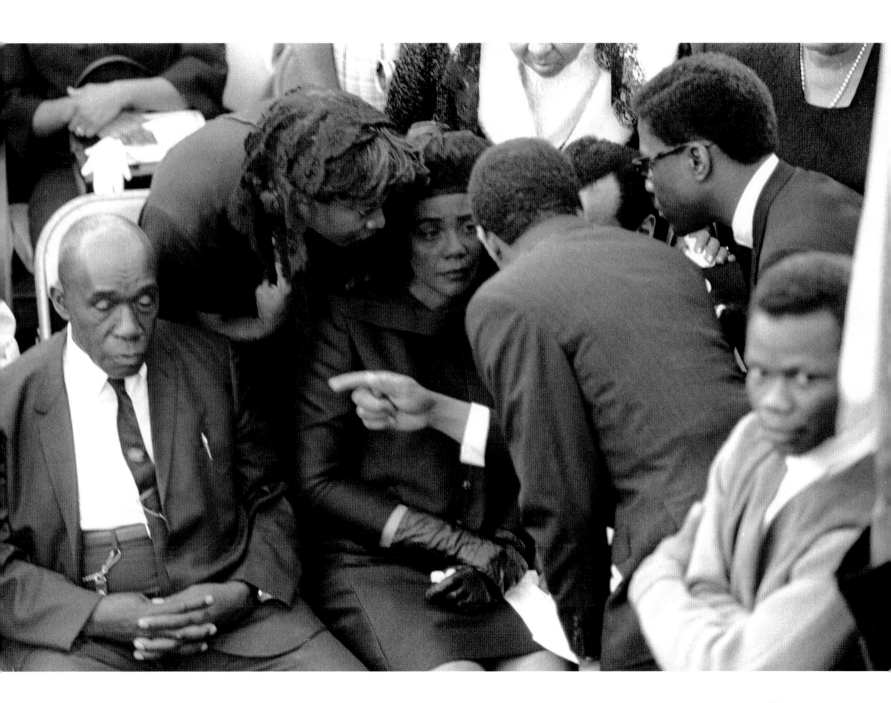

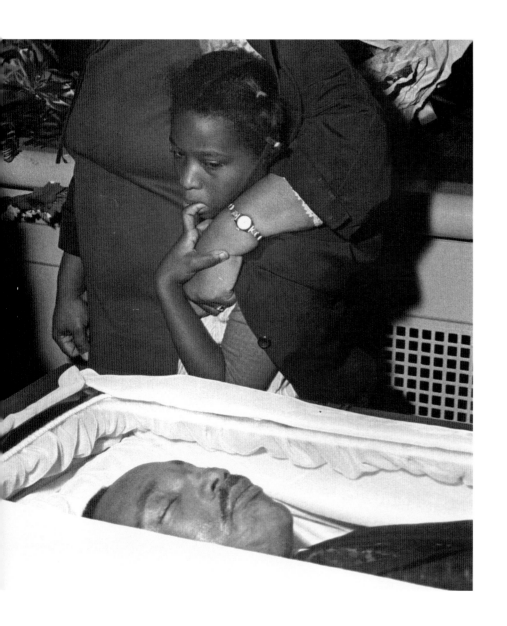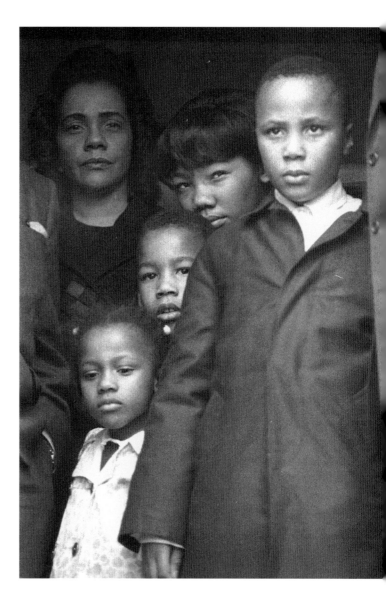

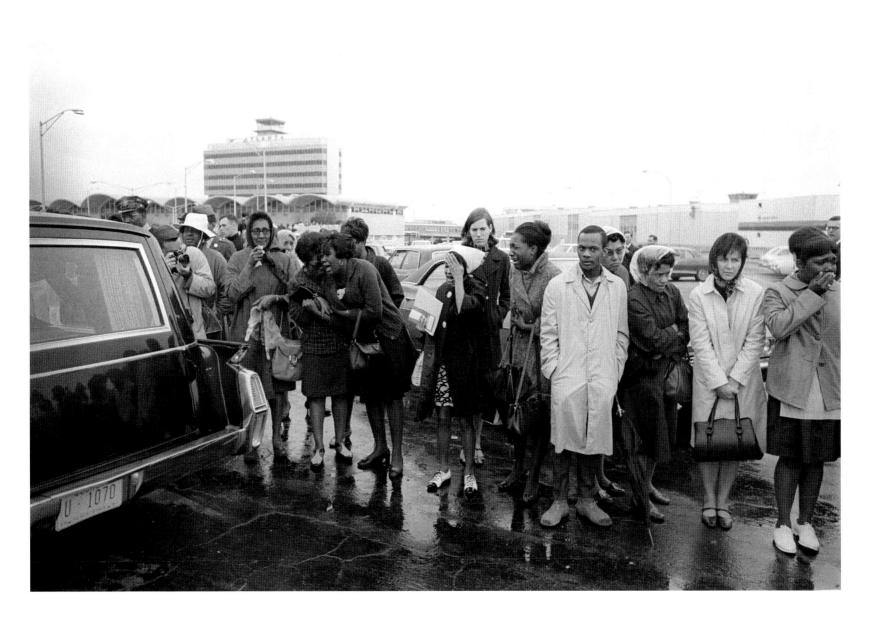

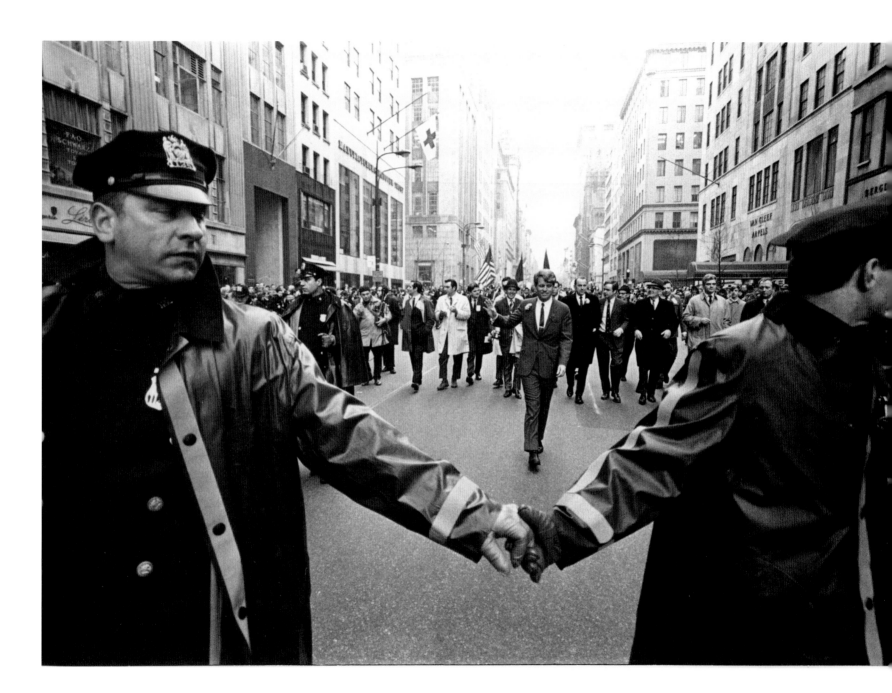

38

photograph of Coretta Scott King and her children as they prepared to disembark from the plane. Amongst the funeral mourners was Robert F. Kennedy whose support for King had been compromised by his increasingly complex relationship with the bureau chief of the FBI, J. Edgar Hoover.

The year 1968 was the year of the presidential election. With the spectre of his own brother's death still looming over him, Robert F. Kennedy prevaricated about whether or not to run for the democratic nomination. In the end, he was persuaded and announced his candidacy declaring that, 'I do not run for the presidency merely to oppose any man but to propose new policies.' Benson photographed him glad-handing the crowds as he marched at the head of New York's St Patrick's Day Parade. Waving from the window of her apartment on Fifth Avenue was his sister-in-law Jackie Kennedy. Within a month his anxieties were intensified by the killing of King.

By 5 June his campaign was gathering momentum. Having secured the Californian primary he headed to the royal suite of the Ambassador Hotel in downtown Los Angeles to celebrate with his party workers. A press conference was timed to catch the late evening eastern time news, broadcasting from New York, three hours behind. For Benson, working to meet the deadlines of English newspapers, there was little reason to attend. The story would have already been filed. He stayed on anyway taking pictures 'that would never see the light of day'. In proposing new policies, Kennedy was inching towards backing a withdrawal of troops from Vietnam. He attracted a youthful and passionate audience given to shouting out 'sock it to 'em Bobby' in

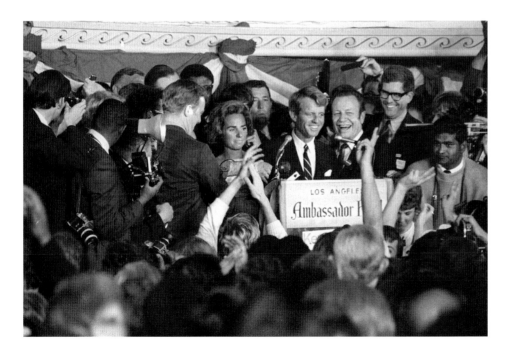

Senator Robert F. Kennedy, New York, 1968
Bobby Kennedy announced his candidacy for the presidency on St Patrick's Day and marched up Fifth Avenue in the annual parade. People rushed into the street to touch him and he would dive into the crowd to shake hands.

Senator and Mrs Robert F. Kennedy, Los Angeles, 1968
Bobby had won the California primary and ended his victory speech at the Ambassador Hotel by saying, 'And now it's on to Chicago.'

chorus to his speech. 'So many thanks to you all', Kennedy finished, readying to leave the stage, 'and now it's on to Chicago, and let's win there.' It was just before midnight when his entourage pushed their way towards the service kitchens. Knowing that the quickest exit from a crowded hall was to follow the candidate, Benson moved with him. A girl screamed, Harry didn't hear the shot but recalls thinking: 'This is it.' He remembers a sudden quiet then mayhem. 'People were shouting "fuck America" and "another Dallas".' The killer, Sirhan Sirhan, an unemployed Palestinian, had sprayed shots from a .22 calibre gun. Other people had been hit, but Kennedy had taken a bullet in the soft tissue behind his right ear. It had entered his brain. Ethel, Robert Kennedy's wife, pregnant with their eleventh child and dressed in an orange and white mini dress, fought her way to be by her husband's side. Harry had climbed up onto a cooker hob and was taking pictures. The adrenaline pumping, Benson kept repeating over and over to himself like a mantra, 'mess up tomorrow, but don't mess up today.' From just feet away he could hear Ethel whisper, 'I'm with you my

Senator Robert F. Kennedy, Los Angeles, 1968
I had followed Senator Kennedy out through the kitchen as he left the Ambassador Hotel and saw him lying on the floor in a pool of blood. It was bedlam, screaming and shoving, and five other people were shot before the gun was wrestled from Sirhan Sirhan's hand.

Ethel Kennedy, Los Angeles, 1968
Mrs Kennedy was led to where her husband lay. She bent down by his side, then stood, turned to the crowd and shouted, 'Give him air.'

Boater on the Floor, Los Angeles, 1968
After the senator's body had been taken to the hospital, one campaign worker placed her hat on the spot where he had been shot.

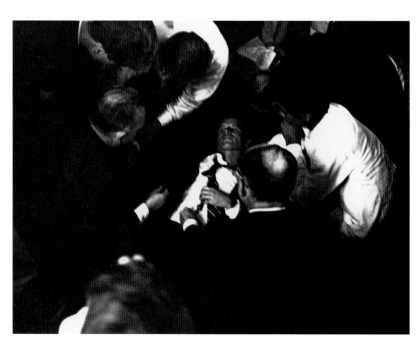

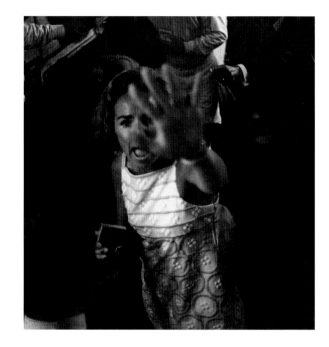

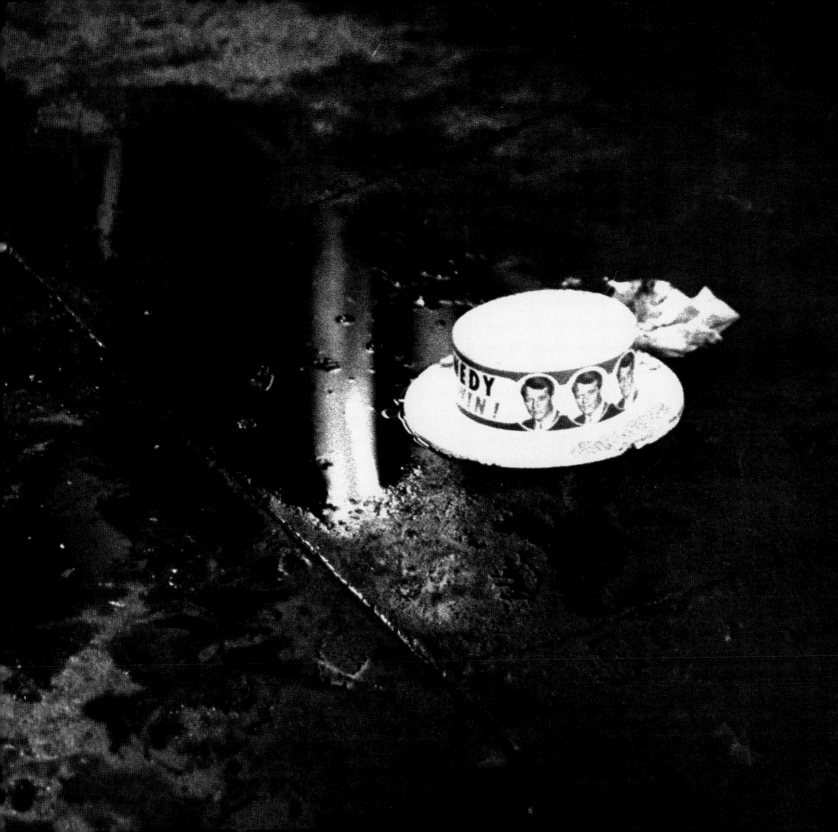

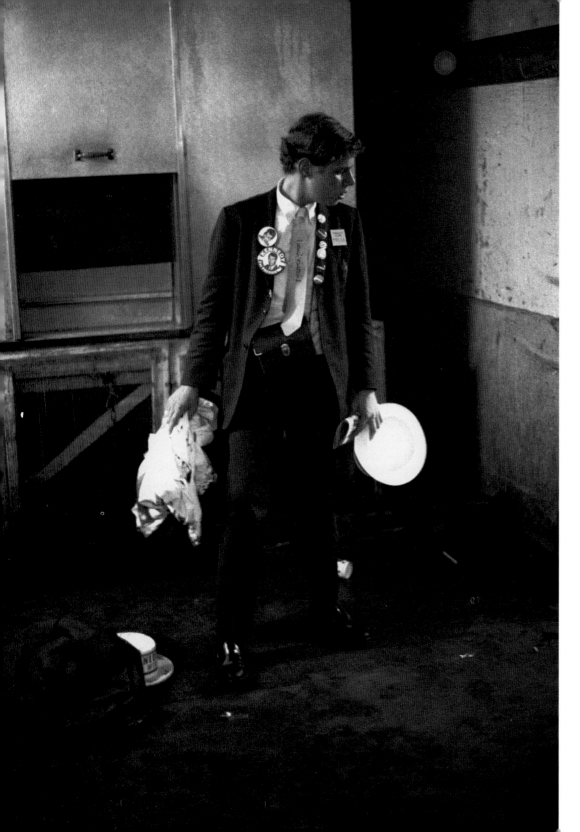

baby,' as she cradled her husband's head in her arms. Ethel turned towards Benson, her hand outstretched, screaming for people to step back to give Kennedy air. '1.4, wide open,' Harry kept thinking. Jessie Andrews, a Kennedy aide, leapt at Benson, pulled him down and smashed a camera against his head. Instinctively, Benson changed films hiding the roll with the precious exposures down his sock in case his camera should be torn from his hands or confiscated by the police.

It took ten minutes for the police and paramedics to arrive. In the chaos the killer had been wrestled to the ground, then squirmed free and grabbed the gun only to be beaten back down again. Harry stayed on and was one of the last to leave. He kept on taking pictures aware that the vivid

Kennedy Campaign Worker, Los Angeles, 1968
I was the last photographer to leave the scene of the assassination. This distraught young campaign worker stood in silence at the scene: everyone was in shock.

RFK Funeral Train, between New York and Washington DC, 1968
Mourners lined the railroad tracks to pay their respect to the fallen senator whose brother, President John F. Kennedy, had been assassinated only five years earlier.

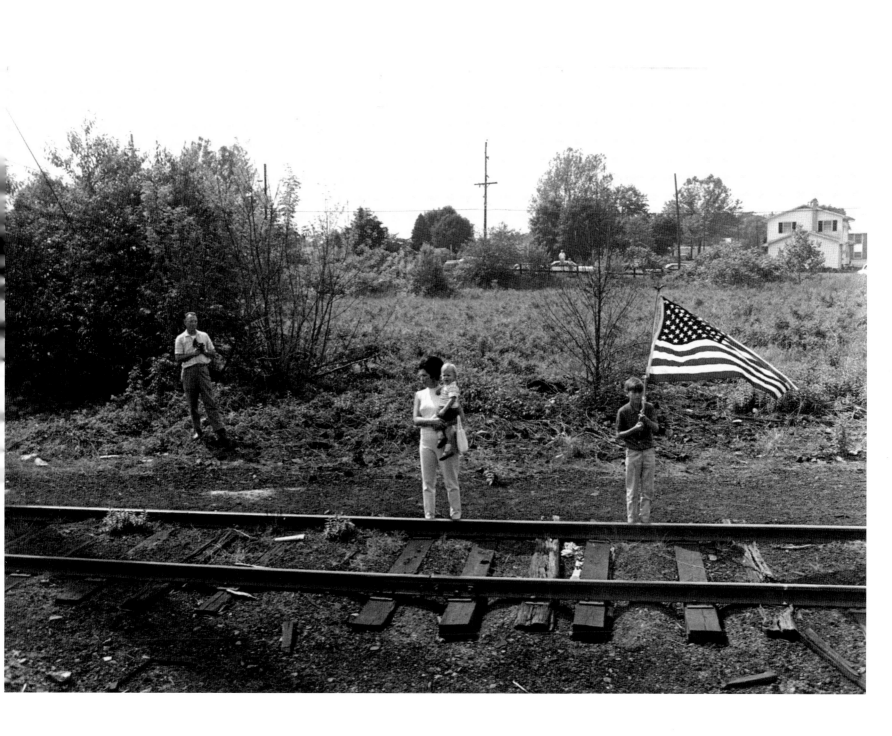

O. J. Simpson, New York, 1972

Truman Capote, Long Island, 1984

Francis Bacon, The Metropolitan Museum of Art, New York, 1975

Greta Garbo, Antigua, 1976

President Gerald R. Ford, on-board Air Force Two, 1973

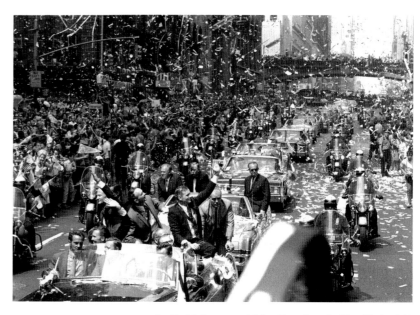

Apollo 11 Astronaut Ticker Tape Parade, New York, 1969

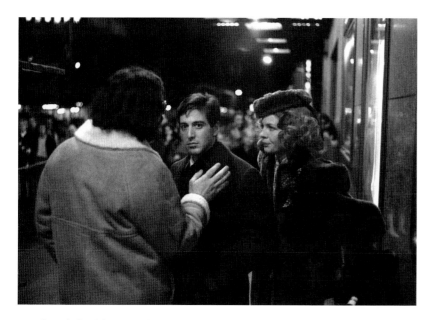

Francis Ford Coppola, Al Pacino, Diane Keaton, on the set of *The Godfather,* 1971

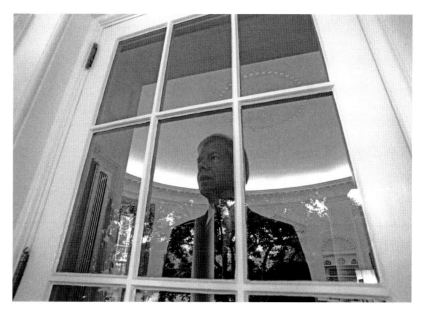

President James E. Carter, the White House, Washington DC, 1979

scene would soon evaporate. His photo-
graphs of the reporters, some too shocked
to file a story, and the young volunteer
campaign workers who gave witness
statements to police, and, in one case, stood
vigil over the murder spot, document the
extremes of human emotion and record a
moment of trauma that would be impossible
to re-enact.

The picture of Ethel Kennedy featured
on the front page of the *Daily Express*, ran
as a 2am special edition, and was repro-
duced around the world. The photographs
won major awards and caused controversy
stirring debate about the ethics of
photojournalism. For Harry, however, the
issue was straightforward. This was a
moment of history and he was there as a
witness with a camera. It was his job to
record things as he saw them and his
journalistic responsibility not to look away.

The photographs were also a watershed;
the moment when he severed his increas-
ingly tenuous ties with Fleet Street and cut
loose to focus fully on the American maga-
zine market and, in particular, the title he'd
regarded as the pinnacle of the industry, *Life*
magazine. 'American journalism', he ob-
serves, 'was as different as night and day. It
wasn't the same cut throat stuff as Fleet

Street, although I admit I might have
introduced a bit of that. *Life* magazine was
like a dude ranch. They really looked after
their photographers.' The assignments
began to roll in and with them the vital
accreditation that would take him closer to
the inner sanctum and nearer to the heart of
things. He had access to the film lots of
Hollywood, the locker rooms of major
sports stars, the private homes of the rich
and powerful and the offices of the White
House.

One of the biggest stories of the time
was of an unlikely hero competing in a
perversely unphotogenic event, the world
chess championship in Reykjavik, Iceland.
The Cold War hung like a dark cloud over
post-war twentieth-century history. As the
two super powers amassed ever greater
arsenals of nuclear weaponry they looked
for every opportunity to lock horns on any
available symbolic stage. The encounters,
when they occurred, veered wildly from the
sublime achievements of the space race to
the more ridiculous arguments between
Vice-President Nixon and Premier
Khrushchev over the relative merits of
American fitted kitchens. The world chess
championship was the latest East versus
West showdown.

Life magazine commandeered a plane to
ferry their journalists back and forth across
the Atlantic. Harry was sent to cover the
preparations and then return for the tourna-
ment proper. To complicate matters further,
James 'Bobby' Fischer was an oddball
maverick as hostile to the attentions of the
Western press as he was paranoid about
the subterfuge of the Soviets. As Harry has
confessed, 'in situations like this there's
usually one friend in the enemy camp. I
thought it might as well be me.' On his first
visit he tried talking to Fischer but got little
more than a dismissive grunt. Benson kept
talking, telling him about how he had
recently photographed the Jets football
legend, Joe Namath. Fischer was suddenly
interested. He had hit a nerve. 'How did he
train? What kind of a man was he? How did
he prepare for the big game?' Harry came
back with a stream of stories, some of them
true, some embellished, some simply made
up on the spur of the moment. Fischer, it
transpired, craved to be seen as an athlete
and as mentally sharp as the top sportsmen
were physically prepared.

When Harry returned for the tournament
he presented Fischer with one of his
photographs of Namath signed, 'Go get 'em
Bobby, Joe.' Fischer was delighted, pinning

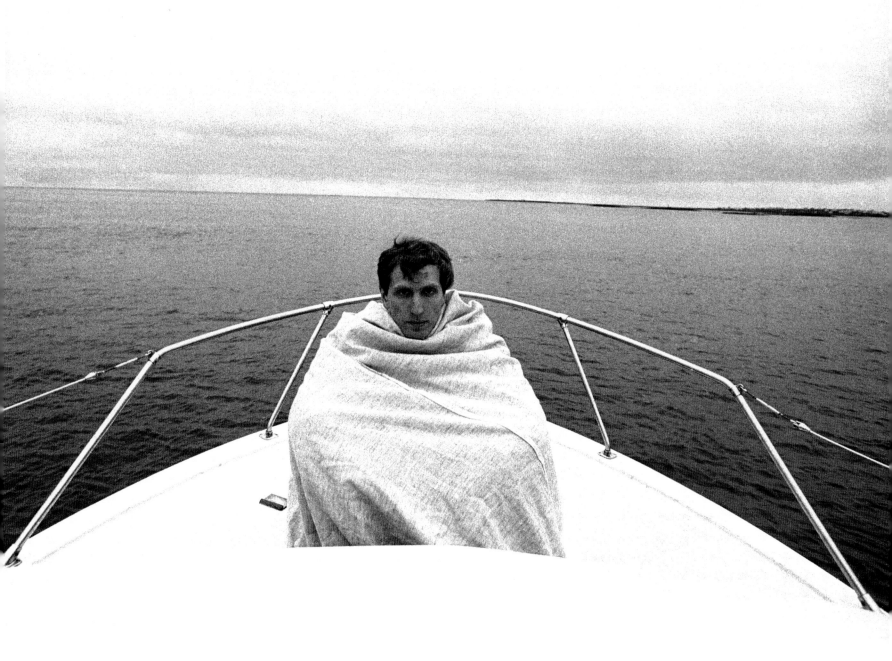

Bobby Fischer, Reykjavik, 1972

During his historic chess match against the Russian grandmaster, Boris Spassky, I photographed Bobby at 3am. As the sun never set and he couldn't sleep, we used to go out every night and walk for miles and miles.

President Richard M. Nixon, Jerusalem, 1972
As he was giving a speech at the Knesset,
I noticed the striking similarity between the
way Nixon held his hands and the Chagall
painting in the background.

Carl Bernstein and Bob Woodward, Washington DC, 1973
The two *Washington Post* investigative
reporters broke the story on the Watergate
break-in that caused President Richard Nixon
to resign from office.

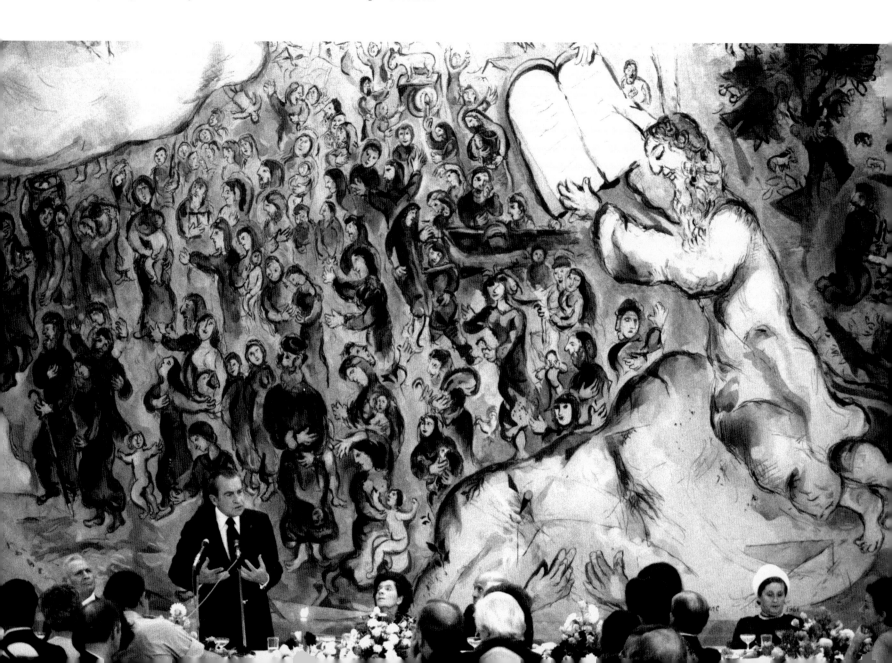

it up in his hotel room. Harry never confessed that he had added the message himself as an afterthought. As the tournament unfolded American news anchors were left explaining obscure chess moves to a bemused American public while photographers had little more to offer than stultifying repetitive shots of two men hunkered down over a chess board with a clock between them. Harry, however, had another angle. In the Icelandic summer the sun almost never set. Fischer settled into a routine of staying up all night, shovelling down a huge hotel breakfast and then sleeping through until the sessions began in the late afternoon.

Each night he would knock on Harry's door and gesture for him to accompany him on a walk. They would head out until two or three in the morning. Harry retuned each day with a fresh set of shots, each one more improbable than the last. He had Fischer wrapped up to his neck in a blanket, sitting on the foredeck of a cruiser pointing out to the ocean, and Fischer sitting in a field being nuzzled by a horse. Sensing they were loosing a propaganda war the Soviet handlers began to suggest that Boris Spassky might be similarly available for late night walks with Harry.

Meanwhile the growing contingent of world press was getting nothing. One morning a group of journalists approached Harry over breakfast. 'Why,' they wanted to know 'would Fischer speak to Harry while ignoring them?' In the corner of the room Fischer was settling down, facing the wall and preparing to devour his customary six eggs and tray of ham. 'The trouble with a lot of people.' Harry helpfully suggested, 'is that they're too uptight around Bobby. Tell a few jokes, blue jokes, just be yourself.' Harry recounts how he watched them

make their way over and attempt this new approach. 'I could see him recoil. When they left he came over. ''Oh Harry, the language they used. The way they spoke to me.'' Bobby hated swearing. I didn't work in Fleet Street all these years for nothing.'

As the tournament unfolded Harry commuted between Iceland and America. On one trip he photographed Pat Nixon taking tea on the Truman balcony. Richard Nixon came in 'obviously agitated and not in a good mood'. Harry recalls telling him, 'I had just come from Iceland with Bobby

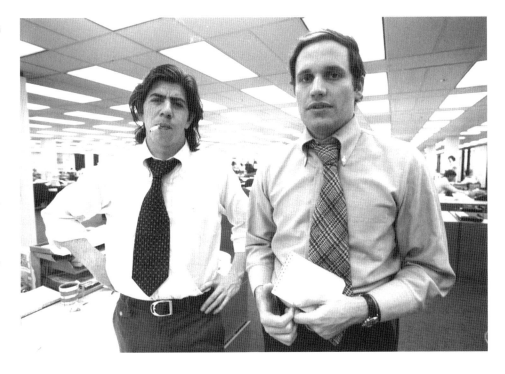

Fischer. He was rather impressed. He said, "Tell that young man when he comes to Washington I'd like to see him." As I left I mentioned to Ron Zeigler, the White House press secretary, that the president seemed rather irritated.'

As the events of Watergate unfolded two years later and private conversations became public testimony, Harry checked back to cross reference the Watergate tapes with his appointment diaries and realised that the moment Nixon had walked onto the balcony was the moment he had just been informed about the bungled Watergate break-in the night before.

Ignominy was heaped on agony as Watergate and the resignation of President Richard Nixon came to bookend America's nightmare decade. Harry, as ever, was at the centre of things. He photographed Woodward and Bernstein, the *Washington Post* journalists who were channelling the revelations of the mysterious 'deep throat'.

Attorney-General John Mitchell and his Lawyers, New York, 1974
John Mitchell had just been acquitted in his first trial in the Watergate break-in and was jubilant. He was celebrating with his lawyers singing an old Harry Lauder song, 'Keep Right on to the End of the Road ' which really impressed me.

He photographed Nixon making his resignation speech, capturing the moment when Pat Nixon's eyes began to well with tears. Most memorably he photographed Nixon's Attorney-General, John Mitchell, as he stood trial and was acquitted. Photographers trailed Mitchell's team from the Manhattan Criminal Court back to their offices. Benson stayed on after the others left sensing there might be just one more picture. Discovering Benson was Scottish, glasses were raised as Mitchell launched into a rendition of the Harry Lauder vaude-ville song, 'Keep Right on to the End of the Road'. Knowing the words, Benson joined in while moving a lamp nearer to the sofa and gesturing for his defence team to come in closer on the couch. Once again, he had his picture.

In December 1971, Harry finally achieved his ambition of being invited to join the staff of *Life* magazine, to be welcomed into 'the dude ranch' on 1 January 1972. Just days after accepting the contract the magazine folded as a weekly title. Undeterred he looked for new outlets; *People, W, Fortune,*

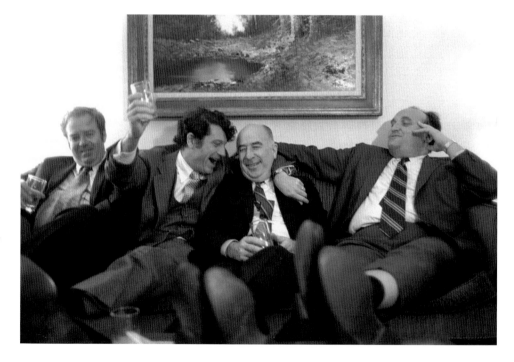

New York, Town and Country, and *Vanity Fair.* Sean Callahan, the former deputy director of photography at *Life,* has written: 'What had pervaded at *Life* and other "serious" picture magazines since the 1950s was a kind of reverential approach typified by the work of W. Eugene Smith where the story was told in a series of dramatic images artfully arranged over several spreads. By comparison, Benson's pictures were irreverent, gritty, casual and stagey, sometimes outrageously so. They told a story in a single image, usually used large in the opening spread, where it dictated the headline, thereby bending the writer's narrative around Harry's photo.'

Harry dusted down his technique, introduced studio lighting into his repertoire and bent the demand for colour-saturated images of celebrities to his carefully honed strategies of guile and persuasion. The approach has come to dominate magazine

President and Mrs Ronald Reagan,
the White House, Washington DC, 1985
On their way to a state dinner, I had five minutes to photograph the Reagans for the cover of *Vanity Fair.* I put on a tape of Frank Sinatra singing, 'Nancy with the Laughing Face'. Mrs Reagan was pleased and the Reagans obliged when I asked them to dance.

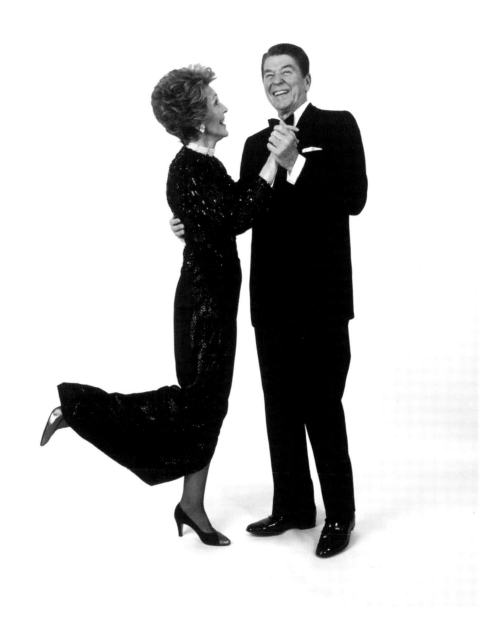

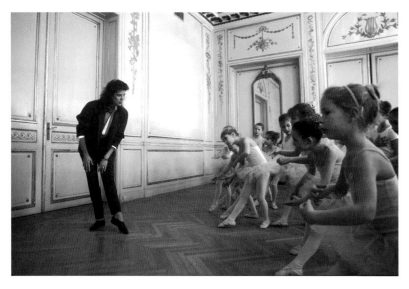

Princess Caroline of Monaco with Ballet Students, Monte Carlo, 1986

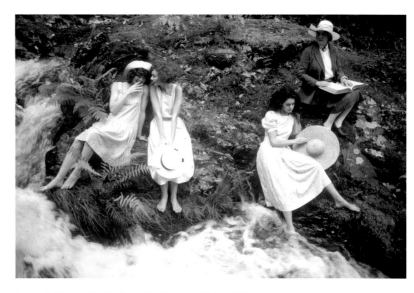

Laura Ashley with Models, Rhydoldog, Wales, 1983

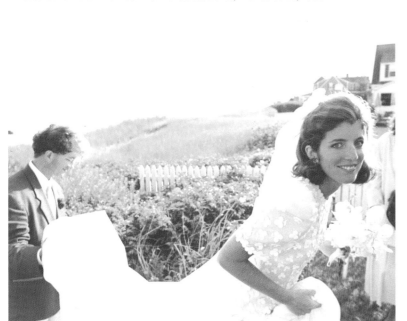

Caroline Kennedy after her Wedding, Hyannis, Massachusetts, 1986

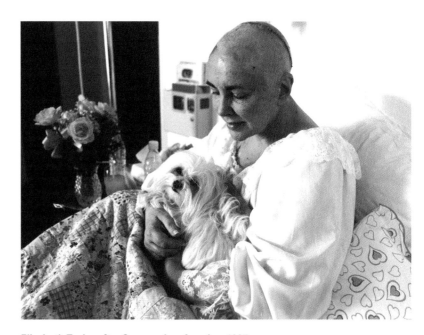

Elizabeth Taylor after Surgery, Los Angeles, 1997

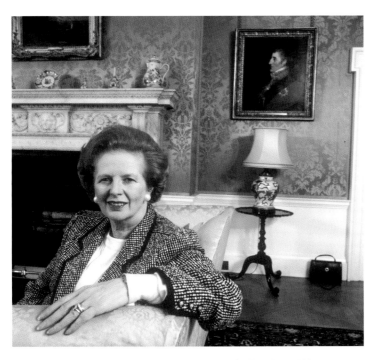

Prime Minister Margaret Thatcher, 10 Downing St, London, 1989

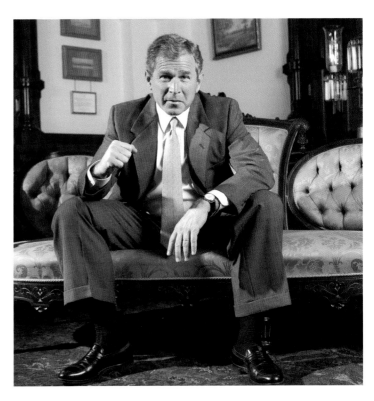

President George W. Bush, Austin, Texas, 2000

Robert Maxwell, New York, 1991

Jack Nicholson, Aspen, Colorado, 1990

culture and has been picked up and developed by everyone from Annie Leibovitz to David LaChapelle. John Lennon's quip that the Beatles were bigger than Jesus still reverberates in a time when celebrity has emerged as a new religion with *Vanity Fair* as the *Book of Common Prayer*.

The potent mix of politics, fashion, art, and Hollywood, liberally laced with a style of photography that Harry was pioneering was principally concocted by Tina Brown at *Vanity Fair* in the mid-1980s. The re-launched magazine, part of Si Newhouse's Condé Nast stable, initially struggled to make its mark and was failing to find an audience. Si Newhouse, it was rumoured, was considering pulling the plug. Harry had just returned from the White House with a remarkable new photograph of Ronald and Nancy Reagan. Tina Brown appealed to Newhouse, arguing that she had a potentially great cover and that he should consider a stay of execution. In the end he relented. Benson had been allocated the White House map room to photograph the Reagans. As the press officers left to collect the presidential couple, Benson and his assistant set up his studio lights and a white seamless backdrop. As a finishing touch he had cued up a song on a tape machine. As they entered the room, dressed for a black tie state dinner, Harry hit play, blasting out Frank Sinatra's song, 'Nancy with the Laughing Face'. The press officers looked alarmed. The Reagans loved it and obligingly danced across the set. Harry asked for and was given a perfect Hollywood ending, a close-up kiss. The entire session lasted little more than the duration of the song.

New readers were magnetically drawn towards this too good to be true image of the dancing Reagans. Copies waltzed off news-stands. In many ways it caught the essence of the Reagans; a synchronised dance partnership, Ronald Reagan's appetite for a joke, their folksy romanticism and their residual Hollywood glamour. It also served as a manifesto for a re-born *Vanity Fair* and proved pivotal in the magazine's fortune.

Benson has carried on ever since. Fresh pictures are routinely minted, every so often a new jaw dropper is added to the maturing archive. Flipping through a magazine we are stopped in our tracks by the audacity of his picture of Michael Jackson, framed outside his bedroom door by two sinister looking child mannequins. We can almost hear Harry's voice emerge from the surface of the picture, 'Ooh what lovely ornaments … the light is a little better over here … if you could just look this way', while darkly thinking to himself 'The gateway of hell.' Harry Benson is never out to deliberately debunk, but is always looking to push the picture as far as it will go – and then take things a little further.

His interest is always with the picture and not in any transient relationship with the person he is photographing. As he is fond of saying, 'who said we were friends? The nicer people are to me, the more wary I become,' he confides, explaining how vital it is to maintain the element of surprise. 'The thing to remember is they're getting prepared for you. That's why I don't see them the day before: coffee, dinner, anything, no matter how nice it might sound. If the reporter meets them first I say, "please don't discuss the pictures, who I am or how I work". I want to go in there when they're cold and I'm hot.'

He is equally capable of pictures of great sensitivity. His portrait of Peg Ogonowski,

Michael Jackson, Santa Ynez, California, 1993
The singer whose *Thriller* album is the best selling album of all time showed me around his home, Neverland. He stopped at the door to his bedroom for a photograph.

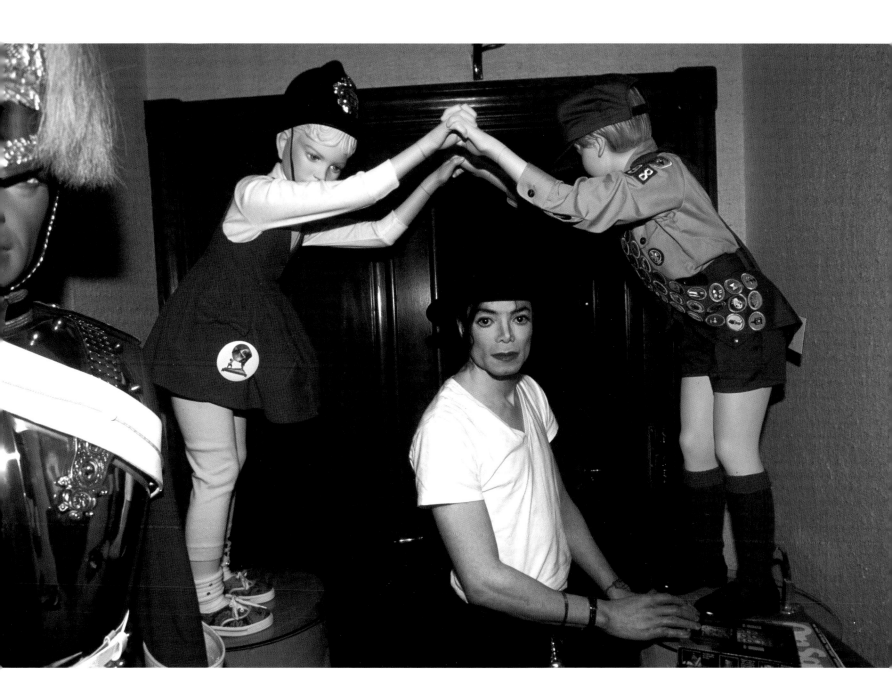

the widow of the pilot of American Airlines flight eleven, the first plane to strike the Twin Towers, has a poignancy that avoids mawkishness. She is pictured sitting next to an empty garden lounger at their home in Massachusetts. The empty chair suggests a loss, but also evokes a more innocent time of flying into New York over Long Island summer lawns.

With Harry Benson producing new work while at the same time plucking the ripening fruits of his vast archive, making books and exhibitions, I ask him what part of the process he most enjoys. He thinks for a while then lights up. 'It's the phone ringing and someone telling me there's a story and it's a good story. It's the promise and the great expectations, and all it conjures up in your mind what you might do. Then they tell you there's a dark side, the person they want you to photograph hasn't spoken to anyone in fifty years. So you've got to do your job and you're thinking about it. That's the best part and that lasts about an hour.'

The next morning the Bensons leave. From across the hall I can hear Harry and Gigi as they wheel out their luggage, each of them with an excitable dog in a carry on holdall. They get in the cab which nudges through the early morning traffic of Third Avenue, up past the apartment blocks with their uniformed doormen around Eightieth Street, through Ninetieth, and on into Spanish Harlem, Harry all the while taking in the new chain stores that are mixing in with this changing neighbourhood. The cab crosses the Triborough Bridge into Queens and on to LaGuardia Airport. Then they're off to Florida, to another job and a new possibility.

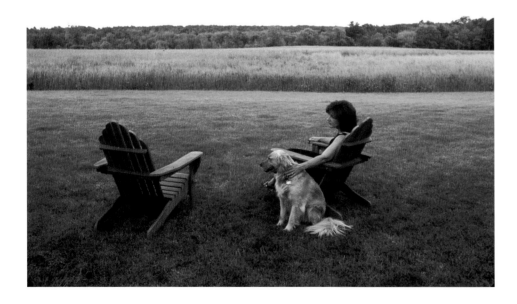

Peg Ogonowski, Dracut, Massachusetts, 2002
Her husband was the pilot of the first plane to hit the World Trade Center. She told me they used to sit in these chairs in their backyard after he would come home from a flight.

Andrew Wyeth, Benner Island, Maine, 1996
One afternoon the artist Andrew Wyeth went out for a walk with a sketch pad to see what he could capture in the misty light and I went along with him. He was a great subject to photograph.

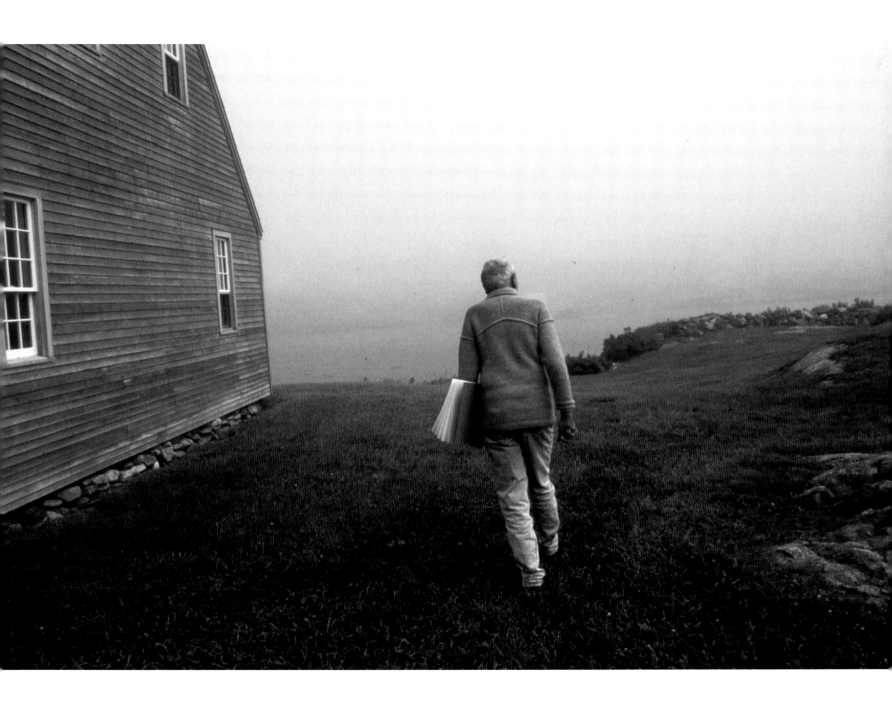

Harry Benson

A witness to many of the last century's historic moments, Benson marched alongside Dr Martin Luther King Jr, stood next to Robert F. Kennedy when he was shot, photographed every American president since Eisenhower, and he covered the conflicts in Bosnia, Afghanistan, Northern Ireland, Iraq (Gulf War), as well as photographing numerous celebrities from Elizabeth Taylor to Michael Jackson.

Outline Biography

1929
Harry Benson born Glasgow

1949
National service in the RAF

1951
Photographer at Butlin's holiday camp for the summer

1953
Becomes staff photographer for the *Hamilton Advertiser*

1957
Becomes freelance photographer covering Scotland for the *Daily Sketch*

1958
Becomes a staff photographer for the *Daily Sketch*. Moves to London

1960
Joins the *Daily Express*

1961
Photographing in Berlin when the Berlin Wall is erected

Photographs John F. Kennedy's state visit with Charles de Gaulle in Paris

1962
Leaves the *Daily Express* to work for *Queen* magazine

1963
Photographs the Shah of Persia

1963
Rejoins the *Daily Express*

1964
Travels with the Beatles to Paris and on their first trip to America

Photographs the world heavyweight championship fight between Cassis Clay and Sonny Liston

1965
Photographs in the Dominican Republic during the Civil War

Photographs the Watts Riots in Los Angeles

1966
Photographs Truman Capote's black and white ball in the year *In Cold Blood* was published

Photographs the Beatles in Chicago in the aftermath of John Lennon's 'Beatles are bigger than Jesus' quip

Photographs Ronald Reagan following his announcement to run for Governor of California

Photographs the civil rights Meredith March through Mississippi

1968
Covers the funeral of Dr Martin Luther King Jr in Atlanta, Georgia

Photographs Robert F. Kennedy in New York following his announcement to run for president

Covering Robert F. Kennedy's Californian primary when the senator is assassinated in Los Angeles

1969
Photographs the parade of the Apollo 11 astronauts through New York following their successful moon landing

1972
Covers Bobby Fischer's world chess championship in Reykjavik, Iceland

Photographs President and Mrs Nixon at the White House the day after the Watergate break-in

1974
Photographs the resignation of President Nixon

Photographs Former Attorney-General John Mitchell following his acquittal on charges relating to Watergate.

1975
Photographs Francis Bacon at The Metropolitan Museum of Art, New York

1976

Photographs Greta Garbo in Antigua

1977

Photographs Andy Warhol

1978

Photographs Shah of Iran shortly before he is deposed

1981

Takes the first photographs of Alexander Solzhenitsyn in America

Covers the famine in Somalia

Covers the IRA hunger strikes in Northern Ireland

1983

Photographs the Mujahideen in Afghanistan

1985

Photographs the USA for Africa recording of 'We are the World'

Photographs Ronald and Nancy Reagan for the cover of *Vanity Fair*, a photograph that revives the fortunes of *Vanity Fair*

1986

Photographs the wedding of Caroline Kennedy at Hyannis, Massachusetts

1987

Takes the first photographs of Mark Chapman since his imprisonment for the murder of John Lennon

1989

Having photographed the Berlin Wall going up in 1961 photographs it being torn down

1990

Covers the Gulf War 'Desert Storm'

1993

Revisits Somalia

1994

Covers the US invasion of Haiti

1995

Covers the O.J. Simpson murder trial

1996

Covers the UN peacekeeping forces in Bosnia

2001

Photographs the aftermath of the 11 September attacks on New York

2005

Photographs the aftermath of Hurricane Katrina in New Orleans

Published Works

Harry Benson on Photojournalism, Harmony Books, 1982; *Harry Benson's People*, Mainstream, 1990; *The Beatles in the Beginning*, Universe, 1993; *First Families: From the Kennedy's to the Clintons,* Bullfinch, 1997; *The Beatles Now And Then,* Universe, 1998; *Harry Benson: Fifty Years in Pictures*, Harry Abrams, 2001; *The President and Mrs Reagan: An American Love Story,* Harry Abrams, 2003; *Beatles Once There Was A Way: Photographs of the Beatles by Harry Benson*, Harry Abrams, 2004.

Exhibitions and Awards

Photographs of the Beatles by Harry Benson was shown in 2003 at Christie's in New York and at the Norton Museum of Art in 2004. Two other photo exhibitions, *First Families* and *The Beatles* are currently touring the US and Europe.

Harry Benson has been twice named Magazine Photographer of the Year by the University of Missouri School of Journalism and the National Press Photographer's Association and twice the recipient of the Leica Medal of Excellence. He has also received the Madeline Dane Ross Award, had forty solo exhibitions and has photographs in the permanent collection of the National Portrait Gallery, at the Smithsonian Institute in Washington DC. Benson has received the 2005 Lucie Award for Lifetime Achievement in Portrait Photography and the 2005 Scottish Press Photographers' Lifetime Achievement Award. His new book, *Harry Benson's America*, Harry Abrams, 2005, was awarded the American Photo Magazine Lifetime Achievement Award for 2005.

Benson lives in New York with his wife, Gigi, who works with him on his book projects. Their two daughters, Wendy and Tessa, live in Los Angeles.

**Mark David Chapman, Attica State
Prison, New York, 1987**
Catcher in the Rye never left his side.
He had this copy with him the night he
murdered John Lennon. He apologised
to me for killing my friend.